IMAGES
of America

LA VERNE

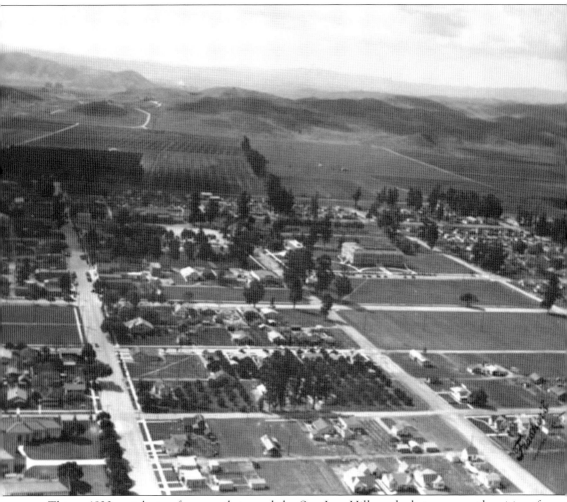

This c. 1930 aerial view faces south toward the San Jose Hills and what are now the cities of Pomona and San Dimas. The Puddingstone Reservoir is visible in the upper right. Citrus was the leading industry, and groves of oranges and lemons are still prominent around the city perimeter. Groves were eventually replaced by houses and businesses as La Verne changed after World War II. (Courtesy of the Frasher Fotos Collection/HJG.)

ON THE COVER: Levin Emory Cannon was one of a series of proprietors of feed and fuel stores in Lordsburg/La Verne. This Autocar truck was necessary for the operation of his business, but he used it to bring some joy into the lives of residents of a nearby orphanage. These girls and boys from the David & Margaret Home for Children look very happy. (Courtesy of David & Margaret Youth and Family Services.)

IMAGES
of America

LA VERNE

Bill Lemon and the La Verne Historical Society

Bill Lemon

Dear Mona,
 Enjoy reading these tidbits about
La Verne's history,
 Very Best
LVHS President

ARCADIA
PUBLISHING

Published by Arcadia Publishing
Charleston, South Carolina

Printed in the United States of America

Library of Congress Control Number: 2020932435

For all general information, please contact Arcadia Publishing:
Telephone 843-853-2070
Fax 843-853-0044
E-mail sales@arcadiapublishing.com
For customer service and orders:
Toll-Free 1-888-313-2665

Visit us on the Internet at www.arcadiapublishing.com

*To Galen and Doris Beery, leaders of the La Verne Historical
Society, and Marlin Heckman, historian and emeritus
archivist and librarian of the University of La Verne*

CONTENTS

ACKNOWLEDGMENTS

When residents of a community collaborate with individuals and organizations who share a passion for preserving history, they nurture a deeper and broader appreciation of civic engagement and create outcomes that reverberate across time and generations. This book is a product of generous efforts by many of La Verne's residents, and although we cannot name every contributor, we would like to acknowledge some with special thanks.

The motto of the La Verne Historical Society is "Preserving Old La Verne's Environment, Making History for the Future." That motto acknowledges that we see farther into the future when we understand our past. Families whose ancestors were part of the original San Jose Rancho, including the Palomares, Macias, and Vejar families, made a lasting contribution to this region. Another unique component of La Verne's history is the presence of families whose ancestors had deep roots in the citrus industry. Some of these families were actively involved in education, business development, faith institutions, and service to others that nurtured the community. The establishment of a school that became a college that became a university that is located in the heart of the historic downtown reinforced the desirability, stability, and community cohesion of La Verne. Thanks go to countless "culture bearers," La Verne's residents who shared stories of their ancestors and their own childhood recollections of helping in the ranches and citrus orchards that dominated the early landscape around the city. Evelyn Hollinger's 1989 publication *La Verne: The Story of the People Who Made a Difference* provided inspiration and appreciation of the energy with which she undertook to capture the contributions of many La Verne citizens.

Ben Jenkins, assistant professor of history and archivist at the University of La Verne, provided images from the university's archives. Paul Spitzzeri, director at the Workman and Temple Family Homestead Museum, as well as members of the San Dimas Historical Society and the Historical Society of Pomona Valley, provided images of La Verne and its surroundings. Mayor Don Kendrick and head of community development Eric Scherer were especially supportive of this project. Members of the La Verne Historical Society Board of Directors who offered their steadfast support and behind-the-scenes assistance included Sherry Best, Donna Dye, Brenda Gonzalez, Ben Jenkins, Clark Palmer, Peggy Redman, and Marvin Weston. Images provided by individuals are acknowledged in courtesies.

We wish to thank the staff at Arcadia Publishing for their instructive support through all stages of publication. Angel (Hisnanick) Prohaska, title manager at Arcadia Publishing, has our special thanks for guiding us through the completion of this publication with patience and persistence.

A chapter in this book focuses on public art in La Verne. Among others, Ruben Guajardo, Eric M. Davis, Joy McAllister, Chis Toovey, and Frank Matranga added enduring beauty to a city that has retained many elements of traditional charm from its early history.

INTRODUCTION

Before the city of La Verne existed, indigenous peoples occupied the land that is known today as the San Gabriel Valley. Their story is a familiar one of conquest, assimilation, and extermination by waves of settlers from Spain, Mexico, and the United States. Culture conflict with Western patterns of land use and forced displacement, coupled with the importation of diseases to which they had little immunity, combined to drastically reduce their numbers. In fact, the designation "Gabrieleño" derives from the Spanish mission established in the area in 1771 and reflects further erosion of the identity of a people more accurately called Tongva or Kizh.

In 1837, Californios Ygnacio Palomares (1811–1864) and Ricardo Vejar (1802–1881) were granted almost 23,000 acres of land by Mexican governor Juan Bautista Alvarado. Named Rancho San Jose, the land had been confiscated in 1834 during the secularization of the Spanish missions in California. Part of the land once belonging to Mission San Gabriel Arcángel, the rancho encompassed many cities in the San Gabriel and Pomona Valleys, including La Verne, Pomona, Claremont, San Dimas, Glendora, Diamond Bar, Azusa, Covina, and Walnut. The grant was enlarged in 1840 with the addition of land granted to Luis Arena, Don Palomares's brother-in-law, who later sold his land shares to Henry Dalton. California was admitted to the United States in 1850, and Palomares, Vejar, and Dalton were granted official patents for their land in 1875.

Rancho land was used primarily for grazing sheep, raising cattle for their hides and tallow, and farming to meet local needs. Dons Palomares and Vejar were renowned for their hospitality to travelers, as their homes replaced the missions as hostelries in an area with few towns. This comfortable existence ended as floods, drought, and financial reverses resulted in land sell-offs after Palomares's death in 1864. The final 2,000 acres of Palomares's land were sold in the mid-1870s. Resulting colonization by farmers began a profound change in land use and population growth.

The city of La Verne was founded in 1887 as Lordsburg and named after its founder, land promoter I.W. Lord. Lord partnered with the Pacific Land Improvement Company to purchase enough land to form a townsite, have it surveyed, and convince the Santa Fe Railroad to build a depot. Lordsburg was incorporated in 1906, and in 1917, the name was changed to La Verne. Although initial farming included grapes, figs, olives, and stone fruits, citrus became the dominant agricultural crop, earning La Verne the title "Heart of the Orange Empire." Packinghouses contributed to the growing local economy, while businesses, schools, and improvements in infrastructure proliferated to meet the needs of an expanding population. La Verne's growth and unique character were also shaped by contributions of members of the Church of the Brethren, several of whom bought the city hotel intended to house visitors hoping to buy and develop land. This hotel served as a private academy (high school) and eventually became a college. Although the original hotel building was demolished in 1927, the college continued to grow and evolved into the present University of La Verne (ULV).

Housing demands following World War II and episodes of blight contributed to the decline of the citrus industry. Groves of oranges and lemons were replaced with housing tracts, light industry,

and businesses. Only three packinghouse buildings remain. Two are owned by the University of La Verne and house its arts and communications departments as well as administrative offices. The third packinghouse is privately owned and houses a packaging materials manufacturer. Approximately 32,000 residents currently live in La Verne.

Like many cities within the orbit of Los Angeles, rapid housing growth led to suburban residential and business encroachment that threatened to obliterate the community's character. With support from members of the city council, a cultural heritage committee was instituted in 1969 and chaired by Rose Palomares, grand-niece of Don Ygnacio Palomares.

Recommendations by this committee gave rise to the La Verne Historical Society, which later merged with a group called SOLVE (Save Old La Verne's Environment), originally formed to enhance and maintain the heart of the original downtown and surrounding residential area. A book celebrating La Verne's history from 1837 to 1987 was written by its city historian and distributed to libraries and local schools. In 1984, the La Verne Heritage Foundation was formed with the goal of preserving the rapidly vanishing citrus industry. A park was established adjoining an orange grove that features an 1883 farmhouse, farm equipment, barns, and animals. Visits to Heritage Park were incorporated into the school district's curriculum. The complimentary gallery exhibit was entitled The Story of La Verne and was developed by the La Verne Historical Society, residents of a city retirement community populated by many descendants of original citrus farmers, University of La Verne faculty, and others. The exhibit compliments the hands-on farm visits and reinforces knowledge of local history for younger residents.

Cities change, and La Verne is no exception. Further development of rapid transit, expanding business opportunities, and housing availability will push residents into areas that were once rural and even considered remote. These changes have been felt by all the cities that grew up along the "citrus belt" along the San Gabriel and San Bernardino mountains, exerting pressure to "upgrade" and "modernize" or even replace historic homes, neighborhoods, and downtowns. However, the history of support by multiple stakeholder organizations, coupled with keen interest by residents, has helped La Verne to maintain its small-town quality-of-life presence.

Images in this book appear courtesy of the La Verne Historical Society (LVHS), University of La Verne Wilson Library Archives and Special Collections (ULVWLASC), David & Margaret Youth and Family Services (DMYFS), Frasher Fotos Collection (FFC/HJG), the Historical Society of Pomona Valley (HSPV), and the Workman and Temple Homestead Museum (WTHM), unless otherwise noted.

One

RANCHO DAYS

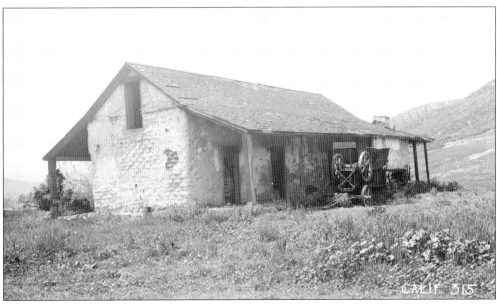

The Carrión Adobe, pictured in a northeast view in 1934, straddled present-day La Verne and San Dimas. Saturnino Carrión built this adobe in 1868 on land he received from his uncle and aunt Ygnacio Palomares and Concepción Lopez Palomares. The Carrión Adobe was restored in 1951 and is now privately owned. (Courtesy of the Library of Congress.)

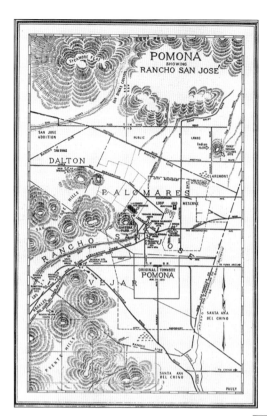

Pictured is a map of Rancho San Jose, created when land from the Mission San Gabriel Arcángel was secularized in 1834. Operated by Palomares and Vejar, Rancho San Jose covered land that now forms the communities of Pomona, La Verne, San Dimas, Diamond Bar, Azusa, Covina, Walnut, Glendora, and Claremont. (Courtesy of the California Historical Society.)

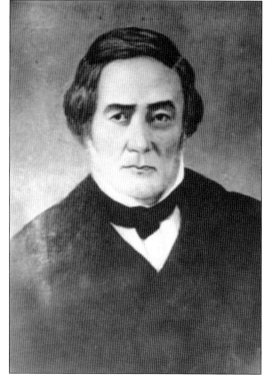

In 1837, Don Ygnacio Palomares (1811–1864), along with Don Ricardo Vejar (1802–1881), received a grant of over 22,000 acres from Mexican governor Juan Bautista Alvarado. Following Palomares's death in 1864, his land was sold until it had all passed from the family by the mid-1870s. (Courtesy of the HSPV.)

Don Nepomuceno Ricardo Vejar (1802–1881) shared the title with Ygnacio Palomares to the land grant that became Rancho San Jose. Additional land was granted in 1840 to Luis Arenas, Don Palomares's brother-in-law. Arenas sold his land shares to Henry Dalton. Poor financial management compelled Vejar to give up his portion of Rancho San Jose in 1864. Vejar and his family lived until 1881 on land that became the town of Spadra. (Courtesy of the HSPV.)

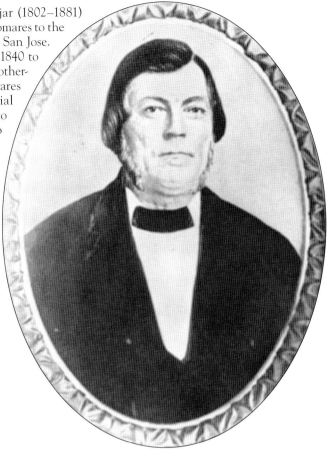

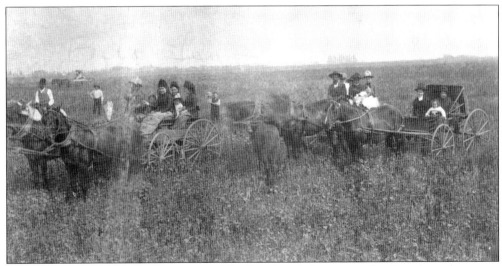

Both Palomares and Vejar were renowned for their hospitality to travelers in a time when town hostelries were rare. The adults and children in the wagon and buggy are dressed formally and may have been traveling to Mission San Gabriel to attend church. Services might also occur at the rancho when a padre visited. (Courtesy of Rose Palomares.)

Jose Dolores Palomares (1841–1909) was the nephew of Ygnacio Palomares. On June 1, 1882, he married Serafina Macias at the Church of Our Lady of the Angels in Los Angeles. The couple had nine children. Jose built a house in the 1880s that was moved to make way when the Santa Fe Railroad was built in 1887. (Courtesy of Rose Palomares.)

Serafina Macias Palomares (1861–1951) was the wife of Jose Dolores Palomares. After her husband's death, Serafina remained in their home at E and South First Streets and enlarged it with a second story and other additions. The home is no longer in the Palomares family but is still occupied as a private residence. (Courtesy of Rose Palomares.)

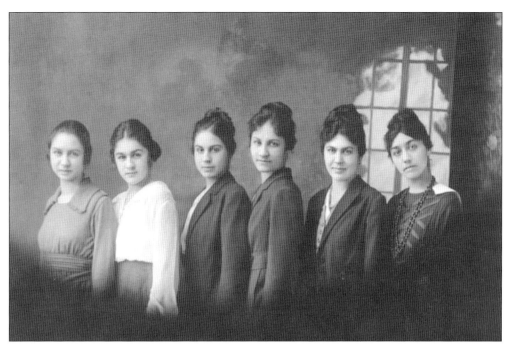

This picture depicts the six daughters of Jose Dolores Palomares, four of whom chose careers in teaching. Rose (1894–1997) was Jose Dolores's fourth daughter and worked to preserve her family's history. She was successful in designating Palomares Memorial Park, her family's original burial area, as a pioneer cemetery. Rose Palomares (left) died at the age of 103 in the home her father built in the 1880s. (Courtesy of the LVHS.)

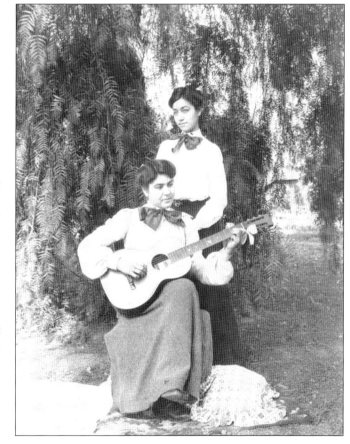

Chonita (seated with guitar) and Margaret Palomares (standing) were two of the six daughters of Jose Dolores and Serafina Macias Palomares. In 1904, Chonita Palomares was the first graduate of the first publicly supported comprehensive high school established in the area. (Courtesy of Rose Palomares.)

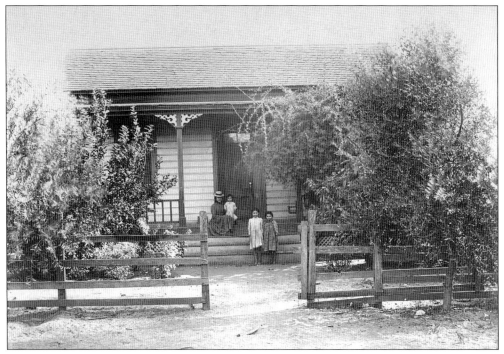

Jose Dolores Palomares built this house in the 1880s. It was moved to make way when the Santa Fe Railroad was built in 1887. This photograph depicts the house in 1895, after it was moved. The infant is Rose Palomares, in her mother Serafina's arms. (Courtesy of Rose Palomares.)

Following Jose Dolores Palomares's death in 1909, his oldest son, Porfirio, supervised an expansion of the home by local contractor Charles Proctor. The remodel was built around the old structure and included front and back porches and a large second story. (Courtesy of Rose Palomares.)

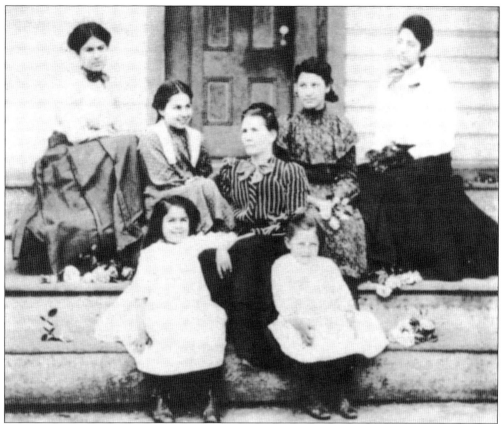

This 1909 photograph shows Serafina Palomares shortly after the death of her husband, Jose Dolores. Serafina is seated in the middle of this photograph. Around her are, from left to right, (first row) Rafaelita and Martha; (second row) Chonita, Rose, Emilia, and Margaret. (Courtesy of Rose Palomares.)

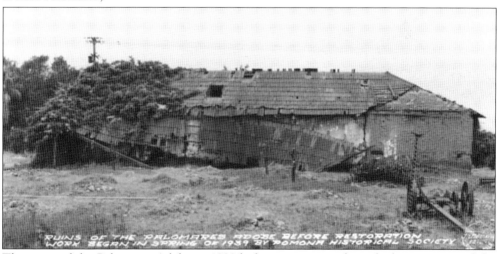

This view of the Palomares Adobe in 1939 before restoration shows little remaining of the original building. Adobe brick and wooden beams from the original structure were salvaged and incorporated into the rebuilt adobe. (Courtesy of the HSPV.)

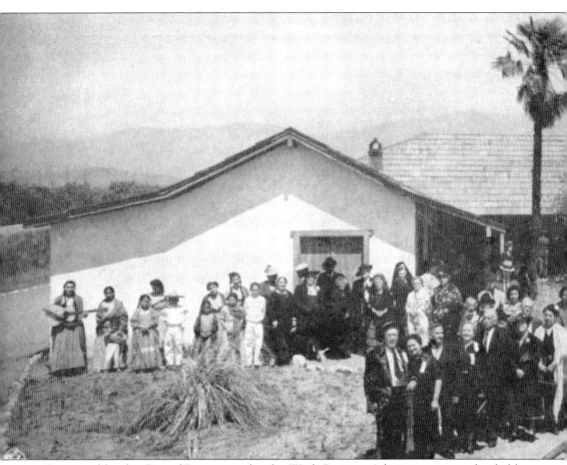

Sponsored by the City of Pomona under the Work Projects Administration and aided by a committee composed of members of the Historical Society of Pomona Valley with input from descendants of the original families, the adobe restoration was completed in 1940. On April 6,

1940, the restored Palomares Adobe was dedicated in a ceremony that included many Palomares family members. (Courtesy of the HSPV.)

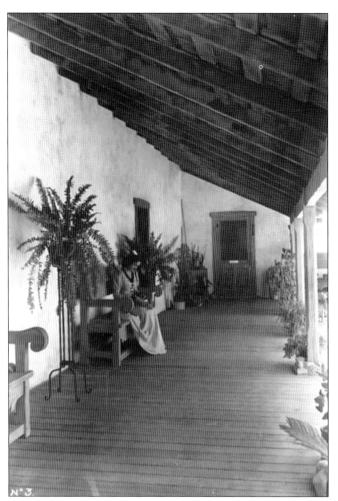

This view of the north wing of the Palomares Adobe depicts daily rancho life. Farming the fields on Rancho San Jose yielded crops for family needs, but the rancho land was used primarily for raising cattle for hides and tallow. The hides and tallow would be taken to coastal port cities to be sold and/or traded for goods not produced on the rancho. (Courtesy of the HSPV.)

The restored Adobe de Palomares is open to the public and serves the community as a place of living history for visitors. Schoolchildren enjoy an opportunity to imagine life on a California rancho when they tour the adobe. (Courtesy of the LVHS.)

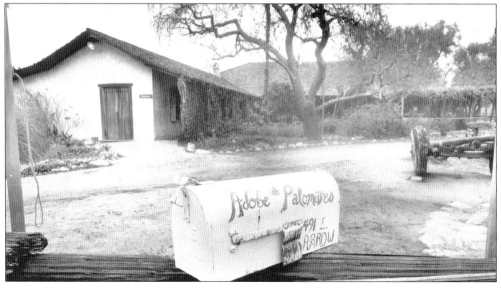

Two

LORDSBURG BEGINNINGS

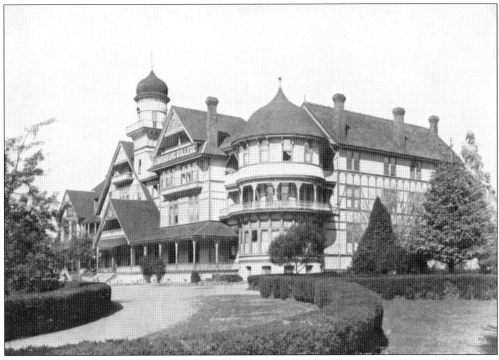

The failed Lordsburg Hotel was purchased by four German Baptist Brethren men to be used as a college. David Kuns, Henry Kuns, Samuel Overholtzer, and Daniel Houser received the deed from the Pacific Land Improvement Company in 1891. The college opened in the fall of that year with 76 students. The former hotel building served the college until the completion of Founders Hall in 1926 and was demolished in 1927. (Courtesy of the ULVWLASC.)

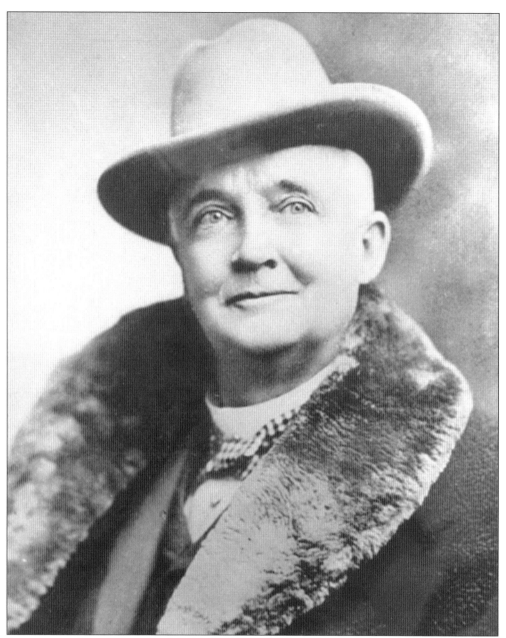

Entrepreneur Isaac Wilson Lord (1836–1917) was a Los Angeles businessman who founded the town of Lordsburg in 1887. Lord owned part of Rancho San Jose and persuaded the Santa Fe Railroad to extend its line through his property. On May 25, 1887, Lord hosted what was reported as the largest land sale in Southern California to date. He sent brass bands through the streets of Los Angeles and San Bernardino, inviting people to a free ride to the new town of Lordsburg. Over 2,500 people accepted the invitation, and they bought $200,000 worth of lots. Building began immediately. Although a fervent booster, Lord never lived in the town he founded and had his home in what is now Rancho Cucamonga. He retired to Los Angeles in 1907 and died there in 1917. That year, the residents of Lordsburg voted to change the city name to La Verne. (Courtesy of the LVHS.)

Clockwise from upper left, Samuel Overholtzer, Daniel Houser, Henry Kuns, and David Kuns received the deed for the Lordsburg Hotel from the Pacific Land Improvement Company in 1891. They became the founders and first trustees of Lordsburg College, which is now the University of La Verne. (Courtesy of Bill Lemon.)

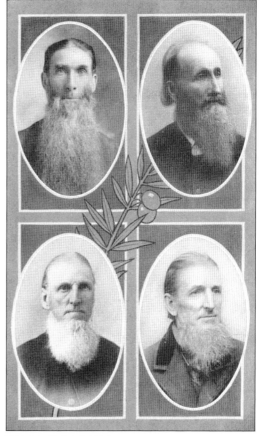

This building housed the Lordsburg Land Office and the post office, advertised shoe repair, and might have had upstairs living quarters. Lordsburg College can be seen in the background, which dates this photograph sometime after 1891. (Courtesy of Mary Williams.)

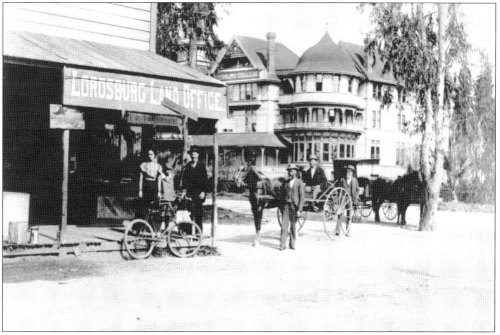

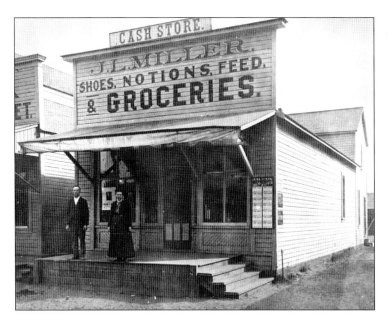

J.L. Miller and his wife, Grace, stand in front of his general merchandise store in Lordsburg in 1903. Built in 1887 and one of the first buildings in the town, the site is now occupied by the Smoke Shop on D Street. General stores at this time carried a variety of items, as referenced in the sign. J.L. Miller eventually moved his business across the street. (Courtesy of Evelyn Hollinger.)

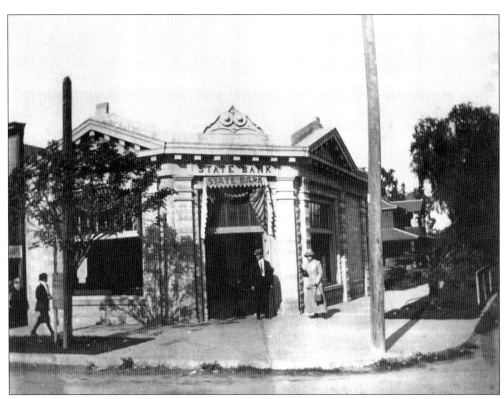

The Lordsburg branch office of the State Bank of Pomona was built by Harvey M. Hanawalt in 1908 on the southwest corner of D and Second Streets. The bank voluntarily closed in 1915. A first-floor addition and a second floor were added in 1921; rooms were rented to college students. The building was eventually demolished in the 1970s. (Courtesy of Evelyn Hollinger.)

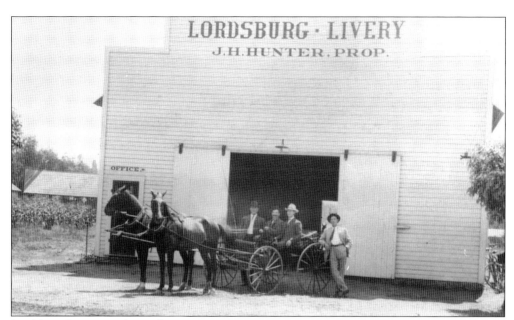

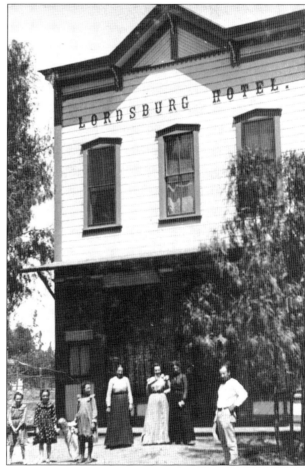

Lordsburg Livery was located on D Street in what is now the 2100 block. Owner J.H. Hunter is driving. Note that the driver sat on the right side of the seat, unlike contemporary American vehicles, whose driving mechanism is on the left. (Courtesy of Arlene Hunter Waltersheid.)

Originally the Pioneer Hotel, this building was relocated to D Street, Lordsburg's main business thoroughfare. After the original Lordsburg Hotel became Lordsburg College, its name was appropriated for this building, which survived into the 1960s. (Courtesy of Hazel Snoke.)

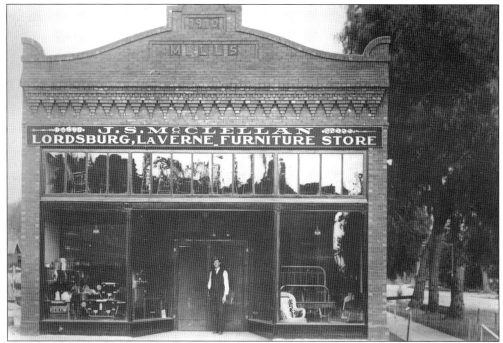

The Lordsburg, La Verne Furniture Store was built in 1910 and housed a business owned by J.S. McClellan. The store's signage was designed to appeal to customers living in Lordsburg and the surrounding area of La Verne. This building is important to city history, as it housed Frasher Fotos. (Courtesy of the ULVWLASC.)

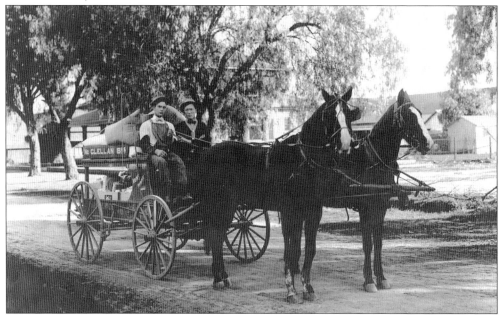

The McClellan Brothers Grocery, like some other businesses in Lordsburg, provided delivery service for their patrons who lived in rural areas. Seated on the left is Jim Fisher, a brother-in-law of the McClellan brothers, and on the right is Hubert T. "Scubie" Mills, a cousin of the McClellan brothers. (Courtesy of Hubert "Scubie" Mills.)

This 1912 Lordsburg City Directory advertisement shows the diversification necessary for maintaining a business in the town's early days. Robert Milne erected two side-by-side buildings (sometimes called a block) where shoppers could find a variety of goods and services. This shopping model has persisted: today's customers can visit a big-box store to have their car serviced while shopping for food, electronics, eyewear, and furniture. (Courtesy of Ancestry.com.)

Alonzo Macias was the uncle of Serafina Palomares and had siblings named Rosa, Ramon, and Concepción. It is likely that this card advertises his business and was found among the effects of the Palomares family. Hypnotism, also called mesmerism, was popular in the 1800s and blurred the lines between medicine and entertainment. (Courtesy of the Palomares family.)

521

Office 11——————— TELEPHONES ———————Residence 459

A. J. MILNE

Studebaker

Auto Agency

Roadsters and Touring Cars
Four and Six Cylinder

Full Line of Accessories

Plumbing Goods

Pumps, Pump Engines
Glide Road Graders and Road
Drags

Real Estate and Insurance

Orange Groves—City Property
Automobile Insurance

318-320 North D Street Lordsburg, California

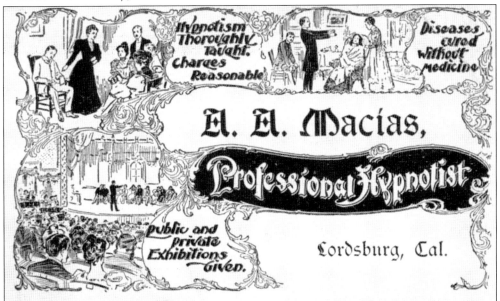

Hypnotism Thoroughly Taught. Charges Reasonable

Diseases cured without medicine

A. A. Macías, Professional Hypnotist

public and private Exhibitions Given.

Lordsburg, Cal.

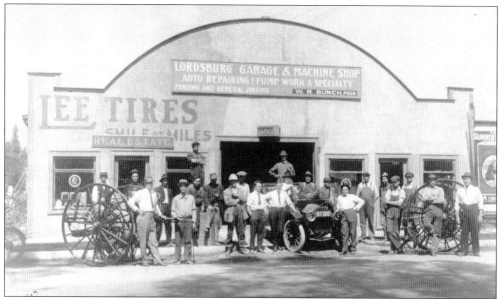

Prior to the building of a fire hall and the acquisition of a fire truck, the volunteer firemen stored their equipment in the Lordsburg Garage and Machine Shop. The equipment consisted mainly of hose carts that the men pulled to the fire and connected to fire hydrants. On occasion, they had the use of an automobile to pull the carts. (Courtesy of FFC/HJG.)

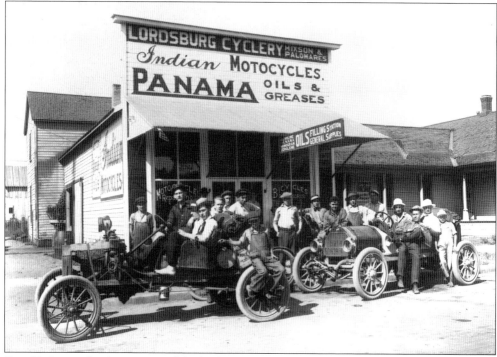

Otto Fink is in the driver's seat of the lead car, and Ray Steves is in the other. They are in front of the Hixson & Palomares Lordsburg Cyclery around 1915. This building was located on the north side of Third Street in what is now the 2100 block. The site is now part of a municipal parking lot. (Courtesy of FFC/HJG.)

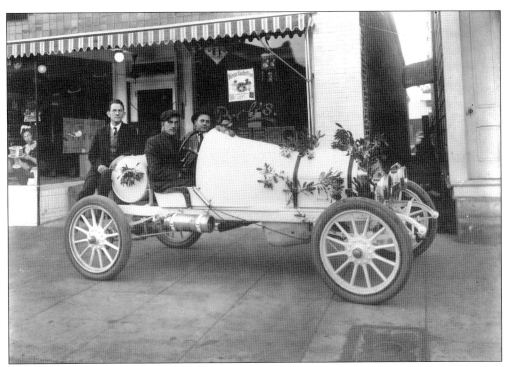

This roadster is posed in front of Bob's Grocery sometime after 1914. Was the decoration for a parade, or an allusion to extending an olive branch? Who is inside the car? The answers are still unknown. (Courtesy of the LVHS.)

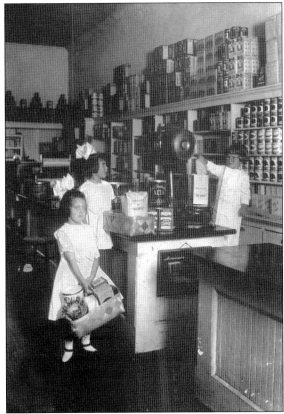

Bob Williams's three children—from left to right, Margaret, Betty, and Boyd—pose inside Bob's Grocery in 1917. This was the building formerly occupied by J.L. Miller's second general merchandise store. (Courtesy of FFC/HJG.)

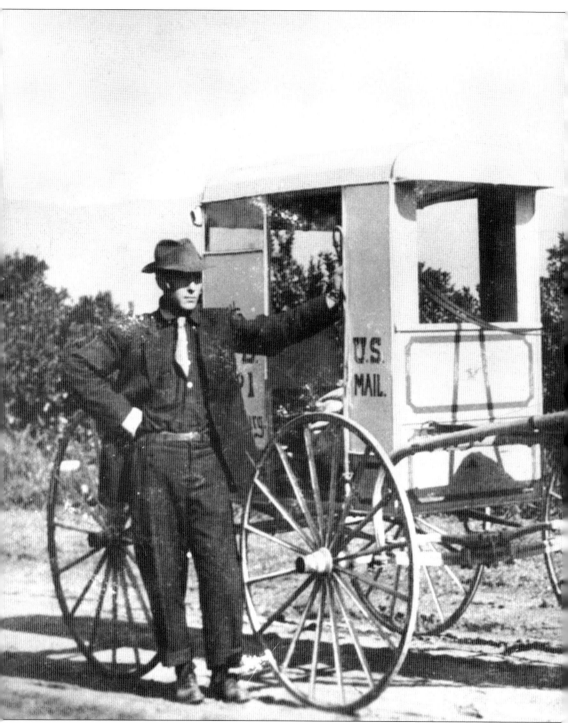

Rural mail delivery began in Lordsburg in 1903. Carrier Hubert T. "Scubie" Mills poses with his horse, Bob, and mail wagon. Mills was Lordsburg/La Verne's second rural mail carrier, taking over the rural route in 1910. Mills gave up his horse Bob for a Ford Model T in 1912, and, at the

time of his retirement in 1955, he had served under seven postmasters. Scubie Mills was also a member of the La Verne Volunteer Fire Department and participated in the Christmas morning candy project for 50 years. (Courtesy of Evelyn Hollinger.)

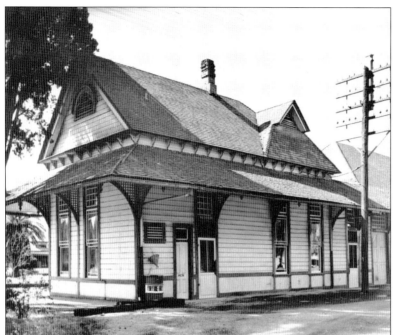

The Santa Fe Railroad came to Lordsburg in 1887 as a result of efforts by I.W. Lord. The depot was conveniently located near the Lordsburg Hotel to accommodate potential land buyers. This structure was torn down in 1952; there is currently no train station in La Verne. (Courtesy of Leo Lomeli.)

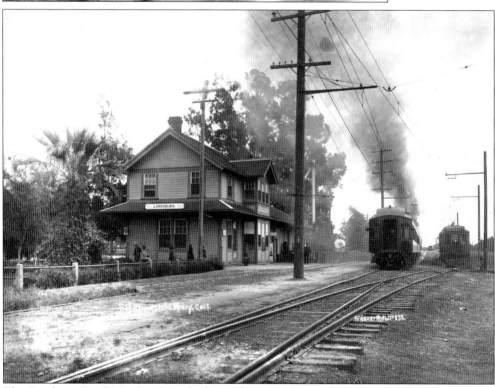

The Southern Pacific Railroad reached Lordsburg in 1896, and the Pacific Electric arrived in 1912. The depot and station agent served both lines. This photograph depicts the steam train of the Southern Pacific on the left and the Pacific Electric car to the side. The depot is long gone, and the tracks were replaced in 1992 when the Metrolink came through. (Courtesy of FFC/HJG.)

Members of the Lordsburg Volunteer Fire Department show off their new American LaFrance Model B Brockway fire engine in 1916. The fire department and city hall were housed in the same building. The cost was $3,400 for the fire engine, paid for with bonds issued by the city. Additional equipment included a "siren whistle" for $230. (Courtesy of FFC/HJG.)

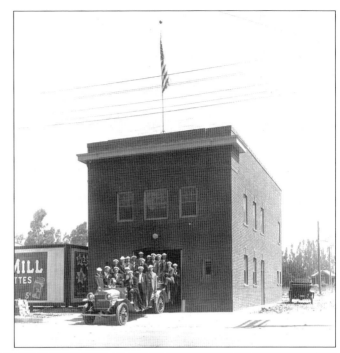

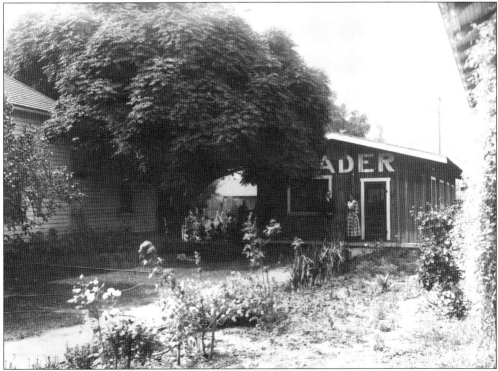

The weekly *Lordsburg–La Verne Leader* began publication in 1910. In 1913, it moved into this newly constructed building on Third Street. The newspaper became the *La Verne Leader* in 1917. In the 1960s, it became part of Bonita Publishing Company of Montclair, but it is no longer published. (Courtesy of FFC/HJG.)

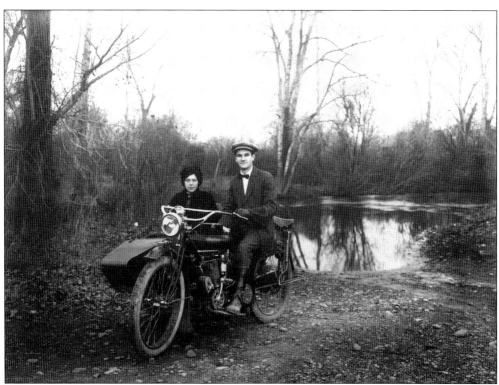

Burton Frasher is pictured with his first wife, Josephine (Angel) Frasher. He operated Frasher Fotos for about seven years before relocating the primary store to nearby Pomona in 1920. Burton Frasher was one of the most prominent photographers in the area; La Verne owes much of its early pictorial history to his efforts. (Courtesy of FFC/HJG.)

From about 1914 to 1920, Burton and Josephine Frasher operated a photographic studio and stationery store at what is now 2306 D Street in Lordsburg/La Verne before relocating the primary store to nearby Pomona. Frasher specialised in all aspects of photograph development and was known for innovative advertising and services. (Courtesy of the LVHS.)

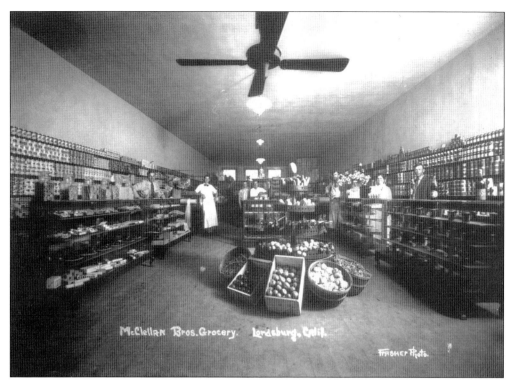

James A. (left) and William D. McClellan (right) are pictured in 1916 with their employees at McClellan Brothers Grocery at what is now 2242 D Street. By 1925, James was running a clothing store and dry cleaner, and William was in real estate in adjoining buildings one block north of this location. (Courtesy of FFC/HJG.)

This photograph of Burton Frasher Jr. appeared on a calendar in 1917 celebrating the city name change from Lordsburg to La Verne. Born in a back room of Frasher Fotos, Burton Jr. also became a professional photographer. His specialty was photographing classes of schoolchildren. (Courtesy of FFC/HJG.)

Mountain Boarding.

HIGH ALTITUDE.

Sunny Rooms and other Pleasant Surroundings.

BEAUTIFUL SCENERY.

Carriage and Buggy or Donkey Hire Reasonable.

ONLY HALF-HOUR DRIVE TO POMONA. TWO MILES FROM SANTA FE R. R. STATION.

DAILY MAIL.

Address, L. H. BIXBY, Lordsburg, Cal.

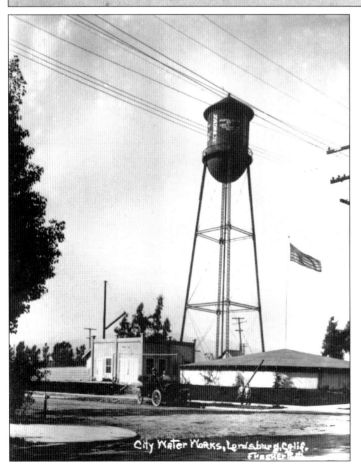

City Water Works, Lordsburg, Calif.

Visitors coming to California for health reasons could have stayed at this hostelry owned by Lewis Hillard Bixby, one of the first settlers in the area. Bixby's wife is credited with naming the area "La Verne," meaning "the Green," or "Growing Green," from the French. (Courtesy of Evelyn Hollinger.)

The Lordsburg Water Works began operating in 1911, when this water tank tower was installed and connected to the city well at the northwest corner of Fifth Street and Lincoln Avenue. The tank was 122 feet high, held 60,000 gallons, and weighed 32 tons. It was dismantled in 1958 or 1959 after being deemed a hazard. (Courtesy of FFC/HJG.)

Henry Lebosquette Kuns (1847–1930) and Mary (Pearce) Kuns (1852–1915) founded the David & Margaret Home for Children, naming the home after Henry's parents—David and Margaret—and their son David. The home provided for orphans; it also served "half-orphans" (children with a living parent who was unable to provide them with a home). (Courtesy of DMYFS.)

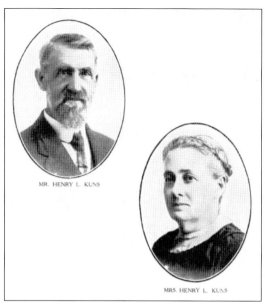

MR. HENRY L. KUNS

MRS. HENRY L. KUNS

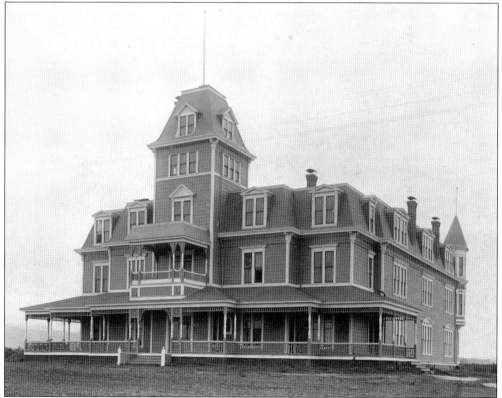

The La Verne Hotel was gifted by Henry L. Kuns and his wife, Mary, in 1910 to the Women's Home Missionary Society of the Southern California Conference of the Methodist Episcopal Church. The hotel and land were used to create a residential orphanage and upgraded prior to opening with hardwood flooring, gas, electricity, water, window screens, a fire escape, and a laundry. (Courtesy of DMYFS.)

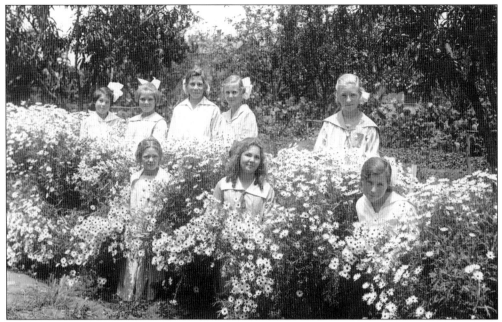

These girls pose among banks of flowers at the David & Margaret Home for Children at its original location. The country atmosphere was enhanced with the addition of a barn to keep the livestock that helped supply meat, milk, and eggs. Henry Kuns donated 700 orange trees to be planted in a grove. (Courtesy of DMYFS.)

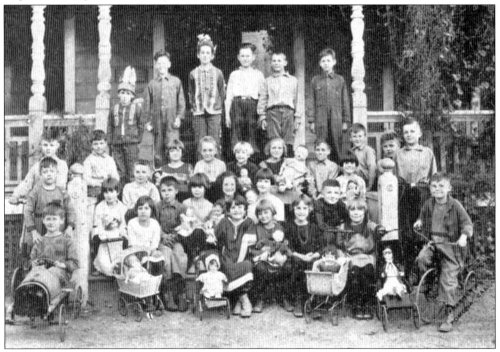

Residents of the David & Margaret Home for Children pose in front of their dormitory, which was originally the La Verne Hotel. Opening with 6 children, by its first year, the organization had housed 93 children ranging in age from 2 to 12 years old. (Courtesy of DMYFS.)

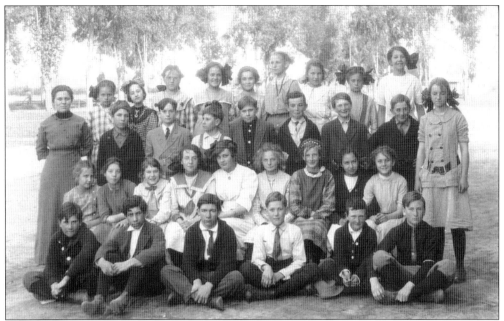

This photograph of children living at the David & Margaret Home was taken in 1915. When possible, parents were expected to pay $10 a month toward the care of their children. Individual and merchant donations, club and auxiliary contributions, and state and county aid provided considerable support. Medical services were provided by Dr. J.E. Hubble, a prominent local doctor. (Courtesy of DMYFS.)

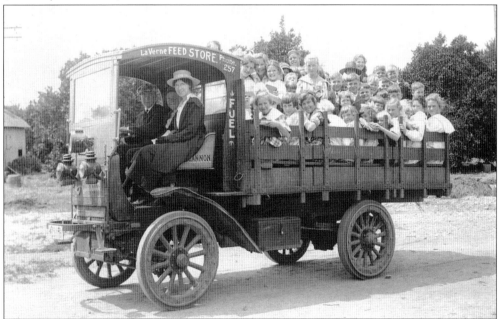

This Autocar delivery truck belonged to L.E. Cannon's La Verne Feed and Fuel Store. It is being used to transport children and matrons of the David & Margaret Home for Children on an outing around 1918. The location is not known, but a citrus grove and pumphouse can be seen in the background. (Courtesy of DMYFS.)

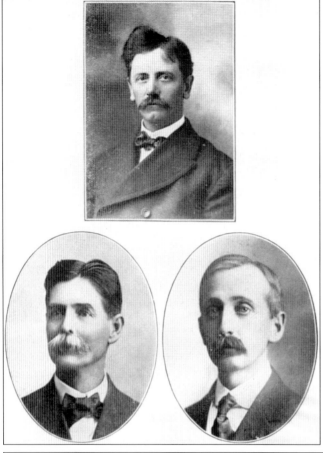

Dr. John Edgar Hubble (top) was president of the Bonita Union High School Board of Trustees. Lewis Hillard Bixby and Lucien Sterling Taylor (bottom row, left and right respectively) completed the group. Dr. Hubble was Lordsburg's first doctor, and Bixby was an original settler in La Verne. Taylor represented San Dimas on the board. The trustees are pictured in 1909. (Courtesy of the LVHS.)

The 1908–1909 faculty at Bonita Union High School were, from left to right, Mary M. Bartruff, Mary K. Miller, Arthur Durward, Elizabeth Wood, and Amy L. Phelps. Durward was also the school's principal. (Courtesy of the LVHS.)

The 1909 Bonita Union High School *Echoes* published this proposed "Course of Study" for the 1909–1910 school year. Note the major categories of study and their progression across grade levels. How would this compare to modern high school curricula? (Courtesy of the LVHS.)

COURSE OF STUDY 1909-1910

LITERARY	SCIENTIFIC	COMMERCIAL
NINTH YEAR		
English Algebra Latin ONE { Ancient History *Phys. Geog. or Botany	English Algebra Latin ONE { Ancient History *Phys. Geog. or Botany	Commercial Foundations Penmanship Rapid Calculation Spelling Correspondence English Ancient History
TENTH YEAR		
English Plane Geometry Latin ONE { Eng. or Mod. Hist. Bot. or Phys. Geog	English Plane Geometry Latin Free Hand Drawing	Bookkeeping Stenography Typewriting English Mod. Hist. or Eng. hist
ELEVENTH YEAR		
† FOUR { Int. Algebra and Solid Geometry English Latin German ‡ Chemistry	Int. Algebra and Solid Geometry Chemistry Geometrical Drawing ONE { German English	Bookkeeping Stenography Typewriting English German or Chemistry
TWELFTH YEAR		
U. S. Hist. and Civics Physics THREE { Latin German English Trigonometry and Adv. Algebra	U. S. Hist. and Civics Physics Trigonometry and Adv. Algebra ONE { German English	Commercial Law and Commercial Geograph Stenography and Typewriting, and Commercial Arith. U. S. Hist. and Civics German or Physics

SCHEDULE FOR ATHLETICS

SECOND THIRD	FIRST THIRD	LAST THIRD
Tennis Basketball	Baseball Tennis Basketball	Baseball Track Tennis

*It is intended to alternate Physical Geography with Botany, and Modern History with English History.

†Any of the subjects, English, Latin or German, begun in the Eleventh Year must be continued through the Twelfth Year.

‡If Chemistry is omitted in the Eleventh Year Physics must be taken in the Twelfth.

With the completion of this building in 1905, Bonita Union High School had its first permanent structure dedicated solely for educational purposes. It was centrally located to serve the three communities of Lordsburg, La Verne, and San Dimas. Its Mission-style architecture was incorporated into the complex of buildings that became Damien High School. (Courtesy of the LVHS.)

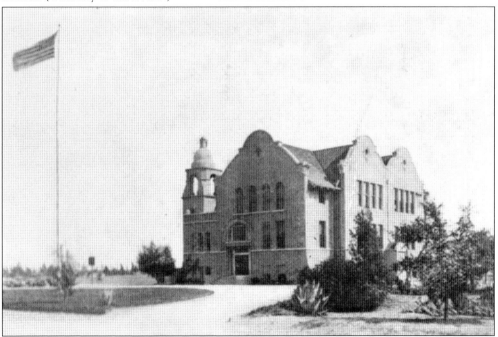

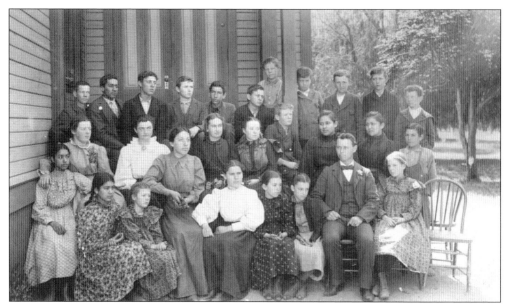

The Palomares District School (above) dates back to 1886 and served the area of what became Lordsburg. The schoolhouse was a two-room building located near the northwest corner of what is now Arrow Highway and White Avenue. In 1896, the school was destroyed by fire, and in 1897, a new school replaced it at the same location (below). The property where the original schools were located had been left to the town by Col. George Heath, an early settler. The deed stated that if the town abandoned the site for "school purposes," the property would revert to Heath's widow. Fortunately, she offered the school district clear title so the land could be sold and the funds could be used to purchase property for a new school. (Above, courtesy of Rose Palomares; below, courtesy of Stewart Wheeler.)

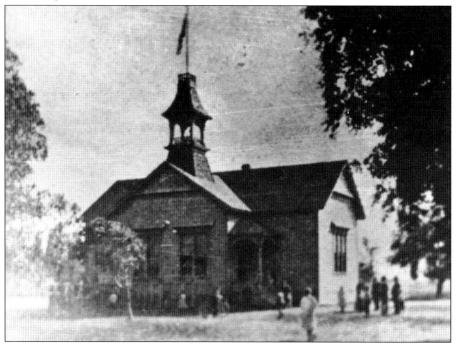

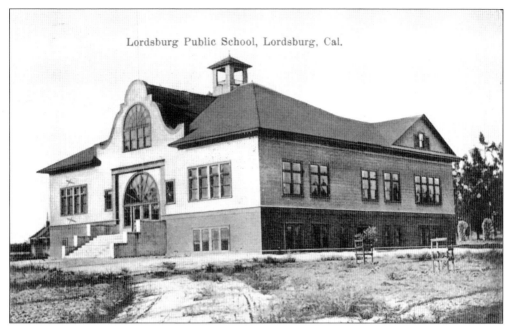

Lordsburg Public School, Lordsburg, Cal.

A bond was approved in July 1905 to build a new schoolhouse in Lordsburg. At the October 1905 meeting of the Palomares School District trustees, initial construction bids were rejected as too expensive. After reopening bidding the following month, a contract was awarded to J.W. Heckman of Pomona with the winning bid of $8,885. The Lordsburg Public (Grammar) School was built in 1906 in the then-popular Mission style. (Courtesy of Cecil Jordan.)

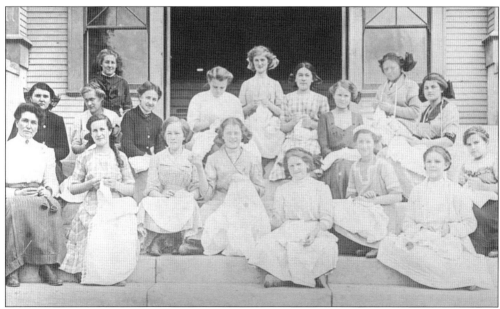

These seventh-grade girls are members of the sewing class at Lordsburg Grammar School in 1911. Domestic and manual arts classes were integral to grammar and high school curricula. (Courtesy of the ULVWLASC.)

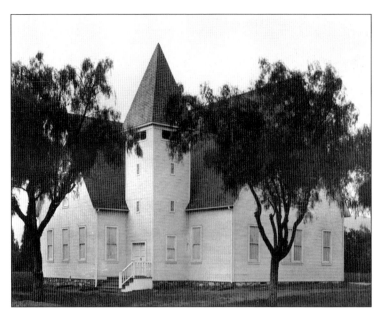

The Lordsburg German Baptist Brethren Church (now the La Verne Church of the Brethren) was organized in 1890. The congregation worshipped in several rented facilities until completing this building in 1902. The first building, with some additions, was adequate until the congregation grew too large. (Courtesy of the Pomona Public Library.)

The Lordsburg Methodist Episcopal Church was built in 1893 and housed the first Christian faith practiced in Lordsburg. After the congregation outgrew the building, it was relocated to the back of the original property to make way for a larger main building, which was completed in 1911. The original church building was then sold and removed. (Courtesy of the ULVWLASC.)

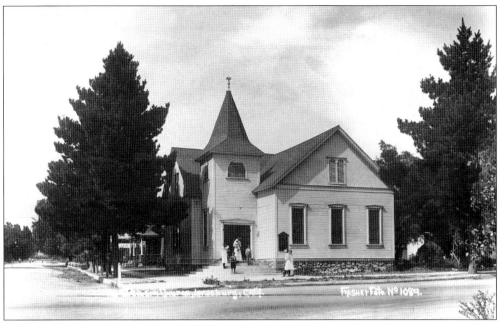

The First Brethren Church of Lordsburg was built in 1901. The small building to the left of the main church served as its parsonage. In 1923, it was torn to its frame, walls, and partitions in a single morning. (Courtesy of FFC/HJG.)

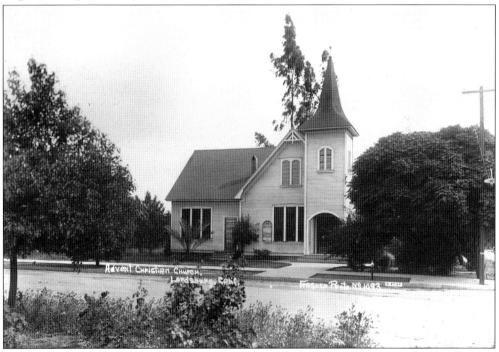

The first building of the Advent Christian Church was dedicated in 1902 and replaced with a new building in 1931. In 1948, the church hosted the wedding of nationally recognized woodworker Sam Maloof and local resident Alfreda Ward. Artist Millard Sheets served as the best man. The church is now known as Bonita Avenue Church. (Courtesy of FFC/HJG.)

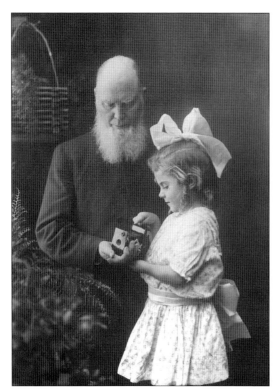

David Norcross and Mary Ellen Minnich discuss a camera. Norcross was an elder in the Church of the Brethren and a veteran of the American Civil War, in which he was wounded and lost an arm. He joined the Brethren in 1876. Mary Ellen's family were members of the La Verne Church of the Brethren, and her father, Leroy, was active in the citrus industry and local government. (Courtesy of Evelyn Hollinger.)

Six of George Hanawalt's sons carry his casket from his house to the hearse prior to his interment in 1913. Born in 1831, his family was among the earliest Brethren to arrive in the United States. George Hanawalt was the father of 19 children and served as a Brethren minister for 48 years. (Courtesy of Eric Scherer.)

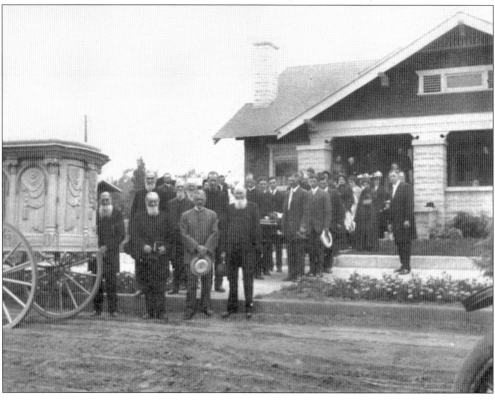

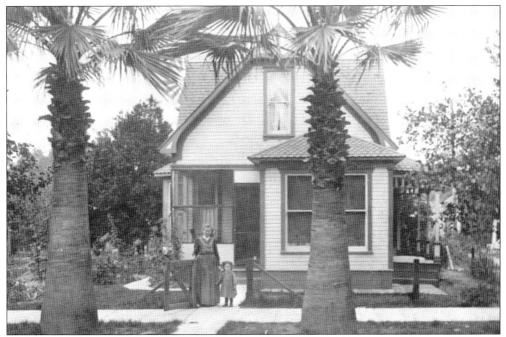

Grace Hileman Miller, one of La Verne's most beloved early citizens, stands with her daughter Lois outside her house on E Street. She remained in this house until her death in 1955. Grace Miller is familiar to present-day local residents because of the La Verne elementary school named in her memory. The street numbering changed, and the house was torn down; only the palms trees that marked the walkway entrance remain today. (Courtesy of the ULVWLASC.)

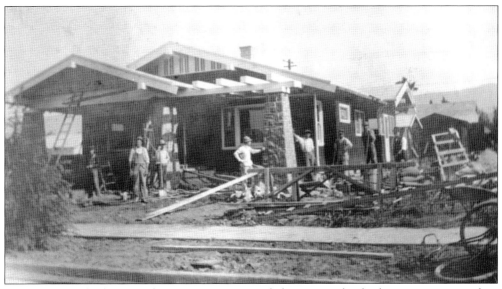

This house was built in 1912 by Harvey M. Hanawalt for W.F. England, who was acting president of Lordsburg College from 1909 to 1911 and a trustee for many years. Concurrently, England was the pastor at the Lordsburg/La Verne Church of the Brethren. The house is a classic bungalow-style building with a deep, front-gabled porch. Exposed beams, rafter tails, and extensive use of stone for foundations and porch columns were characteristic of the style. (Courtesy of the ULVWLASC.)

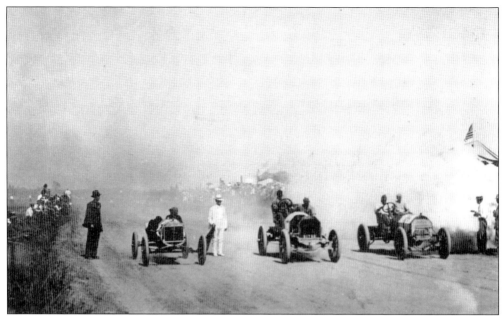

The Lordsburg racetrack was organized in 1904 by members of the San Jose Rancho Driving Club on land owned by the Vejar family. The track was located approximately south of what is now Arrow Highway and between A and B Streets. Automobile racing occurred on the oval track, but the racetrack was also used for motorcycle, bicycle, and horse racing. The Lordsburg racetrack was active until 1914. (Courtesy of the LVHS.)

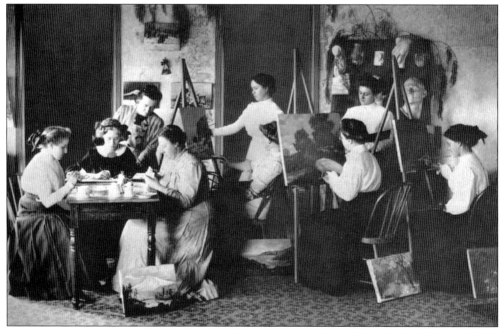

Claudia Evelyn Teague Keiser (standing at left) taught art at Lordsburg College from 1907 to 1910. Additional subjects in her repertoire included science, mathematics, and Greek. It was common for faculty to teach several subjects across what would be separate academic departments at today's colleges and universities. (Courtesy of the ULVWLASC.)

Three

LA VERNE EMERGES

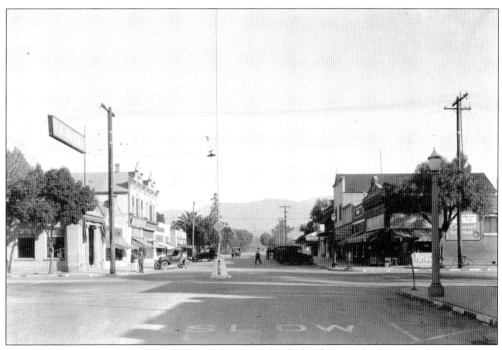

Taken between 1924 and 1931, this view from south of Third Street looking north on D Street reflects expanding commercial life in La Verne. Businesses included two banks, a dry goods store, a variety store, a bakery, a sweet shop, a café, and grocery stores. Other notable features are the "slow" sign on the pedestal that supports the flagpole in the intersection and the electric "LA VERNE" sign overhead on the left. (Courtesy of FFC/HJG.)

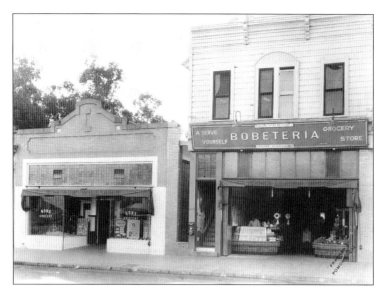

T.H. "Bob" Williams opened Bob's Grocery (left) around 1911 and opened the Bobeteria (right) in 1924. Bob's offered assistance in merchandise selection, credit payment, and home delivery. Bob's customers could also order by telephone. The upstairs of the Bobeteria was rented to students at La Verne College. (Courtesy of FFC/HJG.)

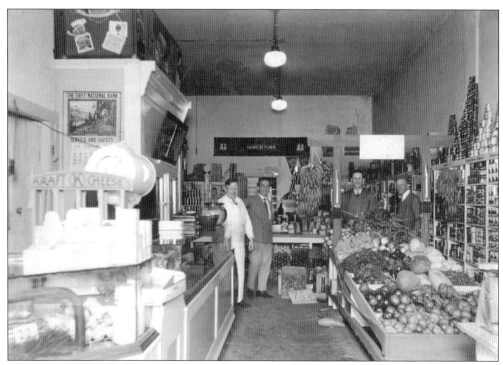

The interior of the Bobeteria shows the shift toward self-service. Amenities available at Bob's Grocery were not offered at the Bobeteria, but prices were lower. Customers helped themselves from shelves, a departure from earlier stores where employees selected goods and boxed them. The 1928 wall calendar is from the First National Bank. (Courtesy of FFC/HJG.)

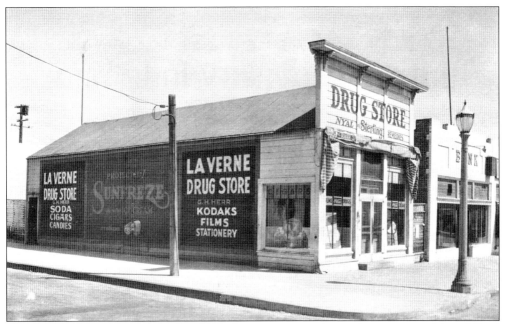

Guy H. "Pop" Herr took over the drugstore of E.C. Kenyon at the southeast corner of D and Third Streets in about 1923 (above). In July 1932, he opened for business at a new location (below). He is pictured with his wife, Minnie, on opening day at 2306 D Street at the northeast corner of Third Street. The old drugstore was replaced with a modern structure. In addition to operating a pharmacy, the new store boasted a soda fountain and sold toiletries and non-prescription medications. The flowers in the foreground are from well-wishers congratulating the Herrs on their move. (Both, courtesy of Evelyn Hollinger.)

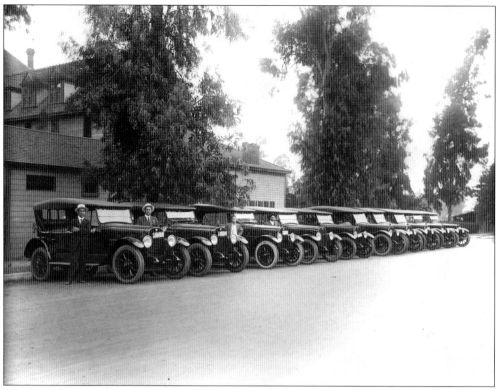

This line of new Hudson automobiles is parked behind the original La Verne College (also known as the Lordsburg Hotel) across Third Street from the car dealership. This was one of a small number of dealerships in La Verne at that time. (Courtesy of FFC/HJG.)

Lucius H. Chapin, Wisconsin-born and whose jobs included streetcar conductor, newspaper editor, and postmaster before he relocated to La Verne, took over the operation of a local service station between 1920 and 1922. This 1924 advertisement by the Chapin Service Station offered three brands of gasoline. Eventually, this station dealt exclusively with Texaco products. (Courtesy of the LVHS.)

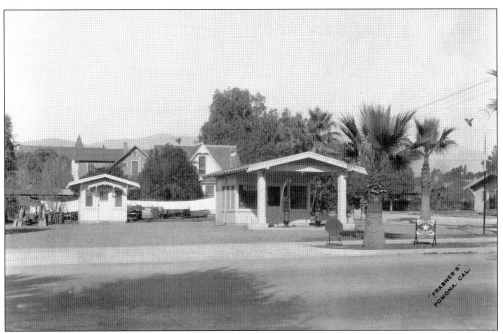

This c. 1924 photograph shows the recently constructed Palms Service Station at the northwest corner of Third and E Streets. In the background at the center is the home of J.L. and Grace Miller. Beyond that and to the left of the Miller home is the former home of Dr. J.E. Hubble. At the time of this photograph, it was occupied by Bertha Harper and her sons Byrl and Chase. (Courtesy of FFC/HJG.)

This cautionary advertisement appeared in the 1927 Bonita Union High School *Echoes* yearbook. Star Grocery replaced McClellan Brothers in 1924 and was replaced by the first La Verne Alpha Beta Food Market in 1928. (Courtesy of the LVHS.)

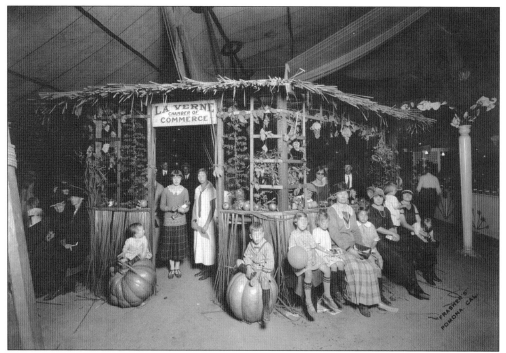

The La Verne Chamber of Commerce exhibited a display at the Los Angeles County Fair during its first year, 1922. The fair ran for five days, October 17–21. The exhibits were housed in large tents. In addition to livestock, exhibit entries included quilts, pine-needle baskets, crochet items, knitting, and cooked foods. (Courtesy of FFC/HJG.)

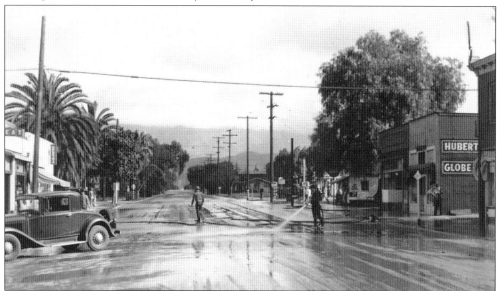

Severe flooding occurred in 1938 after a multi-day storm deposited 11 inches of rain. In La Verne, rain was largely concentrated in the mountain areas above the city. According to local newspaper accounts, a seven-foot stream of water flowed over the top of the local San Dimas Canyon Dam despite opening both floodgates. Flooding from this storm cost over $1.3 billion in damage in today's dollars. (Courtesy of the La Verne Police Department.)

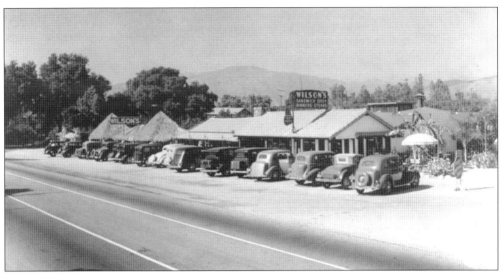

Wilson's very popular sandwich shop was the successor to Wilson's Fruit Market in a prime spot on Route 66, a fabled and nostalgic road that once stretched from Chicago to Santa Monica. The building stayed in the family as Wilson's Dinner House, where it served large groups of diners. In 1966, it became the very popular La Paloma Mexican Restaurant. (Courtesy of the LVHS.)

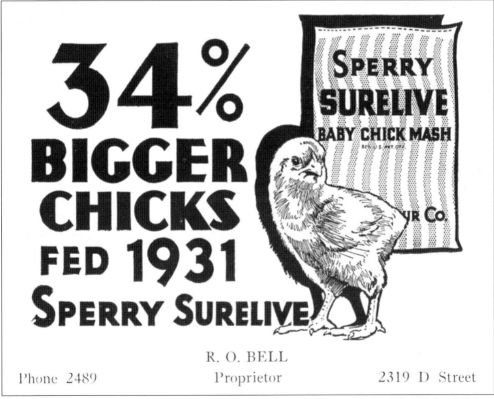

This La Verne Feed and Fuel advertisement is from the 1931 Bonita Union High School *Echoes* yearbook. It is indicative of the prominence of the poultry industry in what was then a highly agricultural area. (Courtesy of the LVHS.)

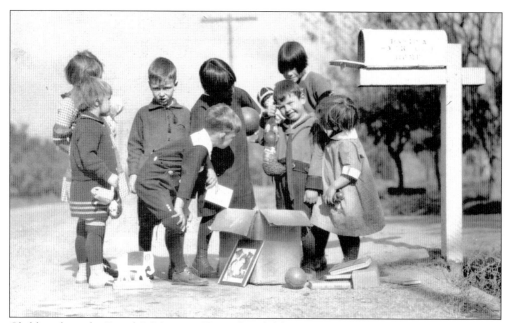

Children from the David & Margaret Home for Children pose for a 1924 Christmas photograph. By the early 1920s, the original David & Margaret Home was insufficient to meet the needs of an ever-expanding group of children. Henry L. Kuns donated 34 acres of land for the new site on Third Street. (Courtesy of DMYFS.)

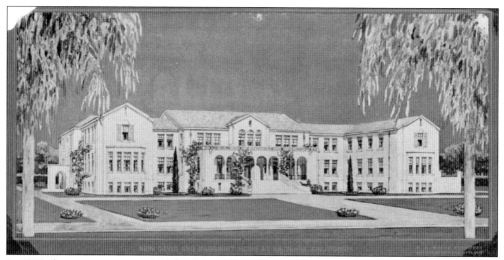

In 1925, the cornerstone was laid for the new David & Margaret Home for Children. The building was completed in 1926. Built of concrete with a tile roof and front facade decorated with ornamental plasterwork, the building still stands and is used for administrative offices. (Courtesy of DMYFS.)

Children are playing on a "giant stride" swing at the David & Margaret Home for Children. Giant strides consisted of fixed center poles and revolving disks outfitted with hanging ropes or chains that ended in short ladders, bars, or rings for grasping. Riders took short steps then long strides until centrifugal force lifted them off the ground and created a flying effect. Popular since Victorian times, giant strides have been removed from playgrounds and parks. (Courtesy of DMYFS.)

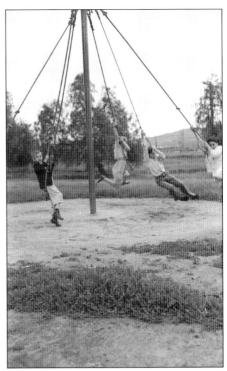

Children are posed in front of the new building at the David & Margaret Home for Children. In 1935, a series of events resulted in the sale and near loss of the home. Incorporation allowed the David & Margaret Home to separate from its original founders and receive bequests and other forms of support. Eighty children were living at the David & Margaret Home during this grueling time. (Courtesy of DMYFS.)

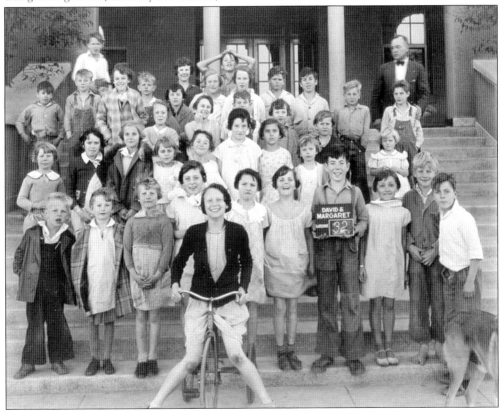

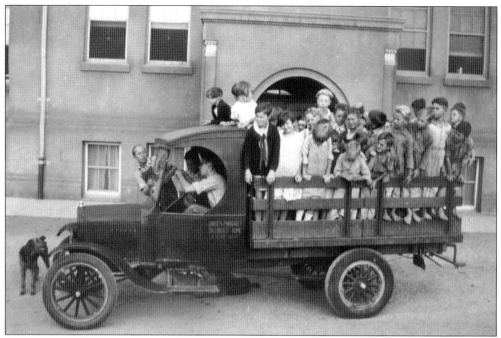

The first vehicle owned by the David & Margaret Home for Children was a Ford, pictured in 1926. Christened "Henry" in tribute to Henry Kuns, the truck body was traded for a covered express body with board seats but was so worn that in 1929 it was traded for a used school bus. A new bus was donated in August 1931. (Courtesy of DMYFS.)

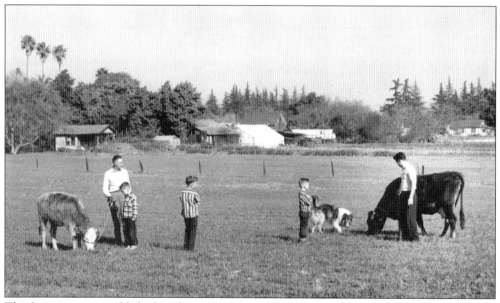

The farm concept established at the original David & Margaret Home for Children continued with cows, horses, chickens, and a vegetable garden. Children learned practical skills in addition to receiving academic instruction. (Courtesy of DMYFS.)

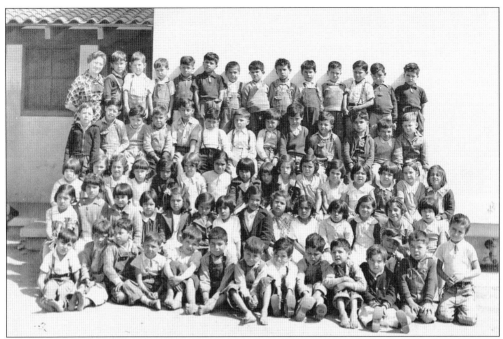

School accommodations were needed for the growing number of children in La Verne. Using the excuse that it was unsafe for children who lived on the south side of town to cross the tracks daily for school, the La Verne City School District built a school in 1927 that was eventually named Palomares School. These two photographs each depict a single class of students (70 in the photograph above, 48 in the photograph below), disproportionately large compared to classes at the other La Verne elementary school. Neighborhood segregation was reflected in the student population, which was predominately Latin American. The "Mexican School" (as it was called) was desegregated in 1947, when all district children in kindergarten through second grade began attending Palomares School and children in grades three through eight began attending Lincoln School on the north side of town. (Above, courtesy of Alice Brubaker; below, courtesy of the LVHS.)

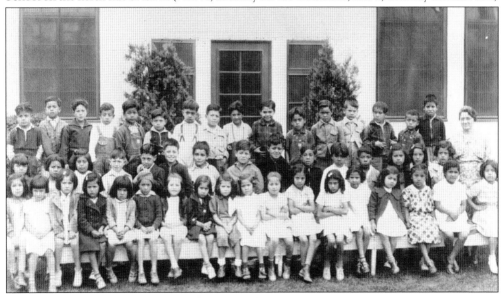

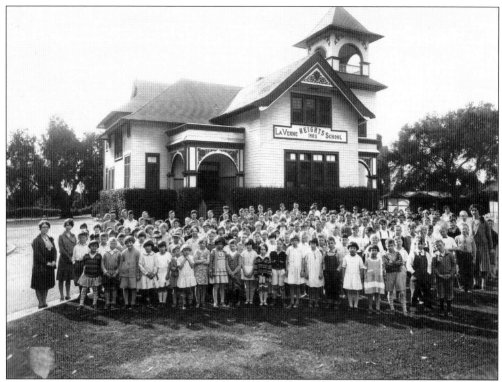

This school was called the La Verne Public School when it was built in 1903. After the city of Lordsburg changed its name to La Verne in 1917, the area where this school was located became known as La Verne Heights. Lordsburg School District became La Verne City School District almost immediately, but this school changed its name to La Verne Heights School in 1920. A new La Verne Heights School was built in 1937 in the same location where this school existed. (Courtesy of the San Dimas Historical Society.)

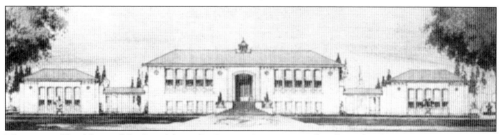

The central building of the Lordsburg/La Verne Grammar School was built in 1906. In 1922, two wings of classrooms were added to the structure, attached by breezeways. This drawing appeared in the local newspaper during the time of the addition. In 1926, the central building was remodeled to match the wings. (Courtesy of the *La Verne Leader*.)

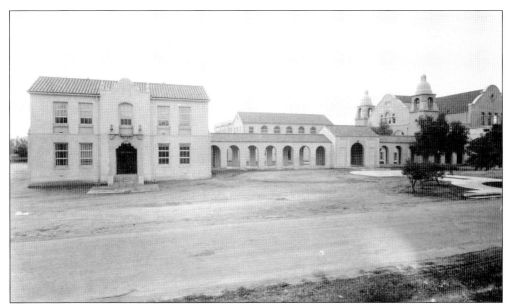

In 1922, the expansion was completed on the Bonita Union High School. The original structure was christened Durward Hall in honor of former principal Arthur Durward. In his dedication speech, Durward stated, "We witness in this magnificent plant the growth of community sentiment in favor of advanced educational facilities for our young people." In 19 years, the school had evolved from a single room over a hardware store to a multi-building complex financed by $30,000 in bonds. (Courtesy of the ULVWLASC.)

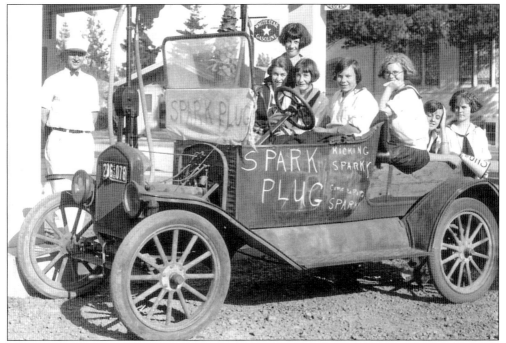

Cecil Jordan, a salesman for the Palms Service Station, is posing with a group of Bonita Union High School girls in the Model T "Spark Plug." The recently constructed First Brethren Church can be seen in the background. (Courtesy of Cecil Jordan.)

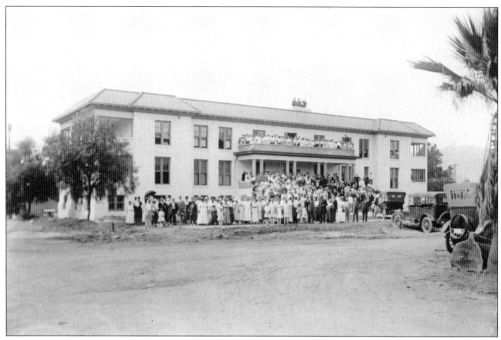

La Verne College expanded beyond the original hotel building to include Miller Hall, initially called the "ladies' dormitory." Built in 1918, it included the library, bookstore, and dining hall. It was formally named Miller Hall in 1926 after Samuel J. Miller, president of La Verne College during its construction. Once the hotel was razed and Founders Hall was built, Miller Hall continued to serve as a women's dormitory and retained the dining hall. (Courtesy of the ULVWLASC.)

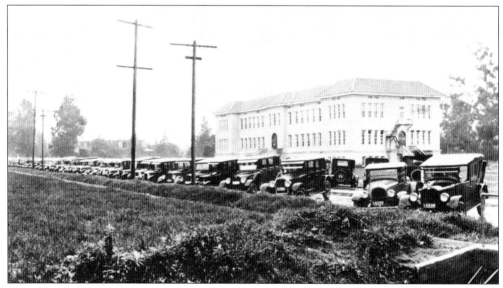

As the former Lordsburg Hotel continued to deteriorate and enrollment grew, the board of trustees began a campaign to erect an administration building, and the contract was let in 1925. The new structure would house offices, classrooms, laboratories, a library, and an auditorium. Named Founders Hall, it was occupied in 1926. It is pictured here on February 13, 1927, dedication day. The remains of the old building are seen on the left. (Courtesy of the ULVWLASC.)

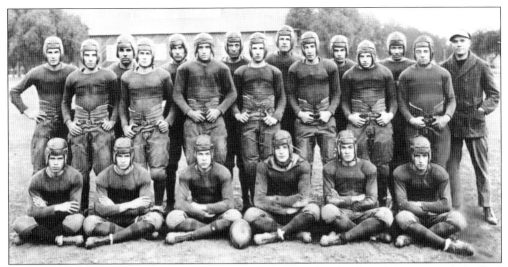

In 1921, the first football game at La Verne College was played. This 1922 team includes Byrl Harper (standing, seventh from left), a high school teacher and later president of the La Verne Historical Society, and Marion Roynon (standing, second from right), after whom a La Verne elementary school has been named. (Courtesy of the ULVWLASC.)

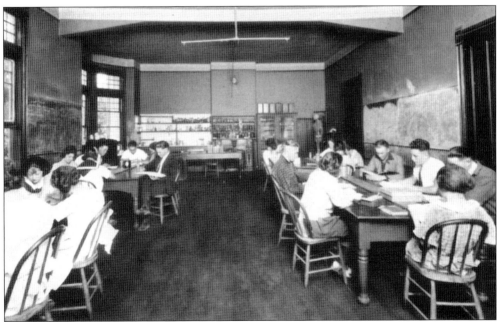

This c. 1923 biology class was located in the main building at La Verne College in the former hotel. Following the name change of the town from Lordsburg to La Verne, the trustees of the college followed suit, and Lordsburg College became La Verne College in 1917. The former hotel was torn down in 1927. (Courtesy of the ULVWLASC.)

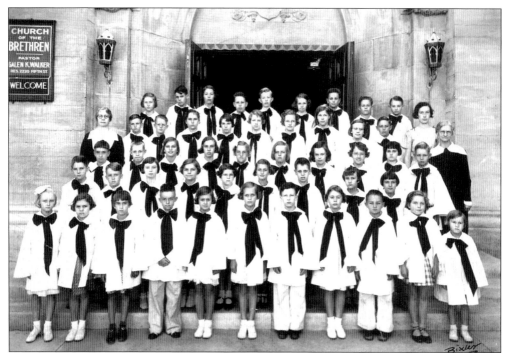

The La Verne Church of the Brethren organized its first children's choir in 1935. Under the direction of Maude Beckner, assisted by Dollie Arnold, and accompanied by Mary Ebersole, the choir performed on the last Sunday of each month at the morning church services. The Church of the Brethren continues its tradition of music as an important part of worship. (Courtesy of the La Verne Church of the Brethren.)

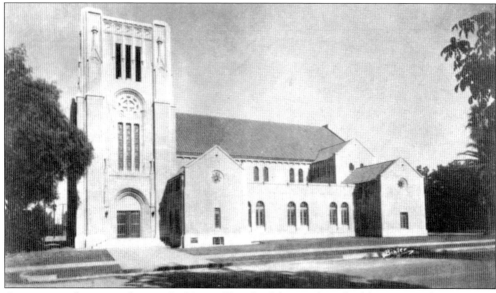

Construction began on the new La Verne Church of the Brethren building in October 1929 and was completed in August 1930. It was constructed of reinforced poured concrete and represented an innovation from earlier building materials. This building and its later additions remain in use today. (Courtesy of the LVHS.)

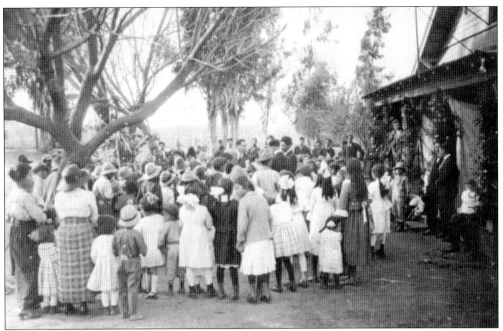

The photograph above shows participants at the Mexican Presbyterian Mission at Christmastime 1920. The celebration was held at a private home in La Verne and organized by the La Verne College Mission Band (a student group organized to perform mission work). In addition to receiving treats and toys, children engaged in baseball and opened piñatas. A supper of special dishes was enjoyed, followed by a program of singing and prayer. Over 170 people participated in this event. The Mexican Presbyterian Mission began in 1918 and organized as a church in 1921. The building pictured below was constructed in 1927 and dedicated as Iglesia Presbiteriana Emmanuel as a permanent place of worship for this group. (Above, courtesy of Florence [Kreps] Barnhart; below, courtesy of *La Verne Magazine*.)

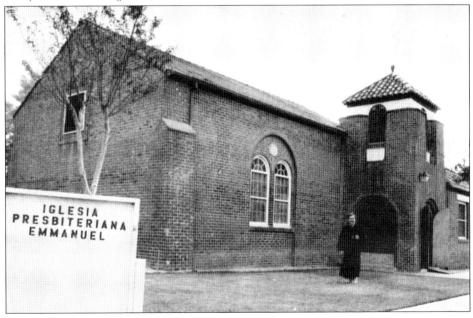

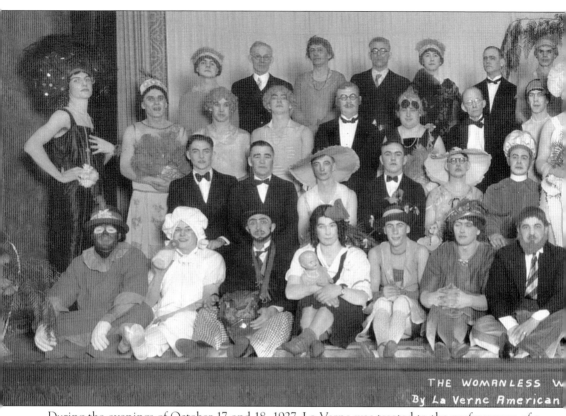

THE WOMANLESS W
By La Verne American

During the evenings of October 17 and 18, 1927, La Verne was treated to the performance of a "Womanless Wedding." Sponsored by La Verne Post 330 of the American Legion, it was held in

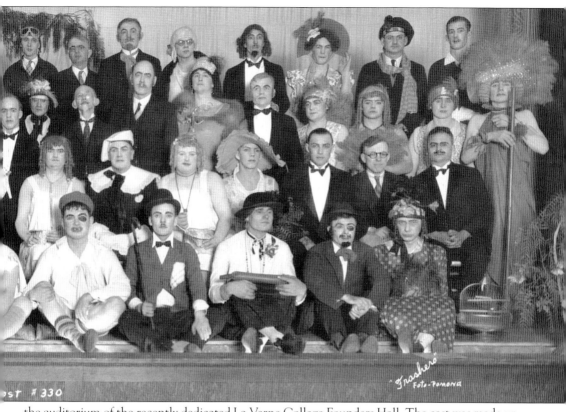

the auditorium of the recently dedicated La Verne College Founders Hall. The cast was made up of local business and professional men, laborers, and students. (Courtesy of FFC/HJG.)

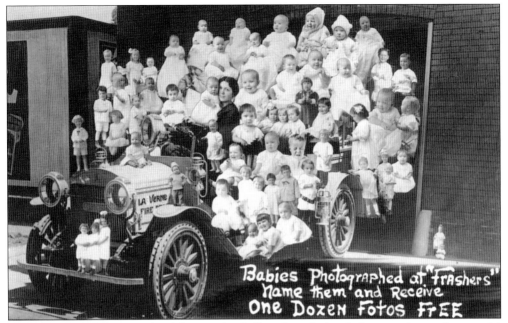

Using a previous photograph of the city fire hall and truck, local photographer and masterful advertiser Burton Frasher superimposed images of babies photographed at his studio. Frasher offered free photo processing of one dozen images if customers could identify all the babies in this picture during his "Annual Baby Month." (Courtesy of FFC/HJG.)

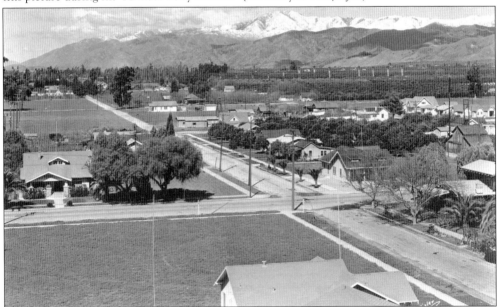

In 1930, local Brethren photographer Joseph B. Bixler took a series of photographs from the nearly completed La Verne Church of the Brethren tower. This view faces northwest toward the San Gabriel mountains. The house at the left of the intersection of Fifth and D Streets was built by Harvey Hanawalt. At the rear of the image is a row of palm trees planted along Firey Avenue (now Wheeler Avenue). Located on the western boundary of the current Hillcrest retirement community, the palms are popularly known as "the twelve apostles." (Courtesy of the LVHS.)

Four

RISE AND FALL OF THE CITRUS INDUSTRY

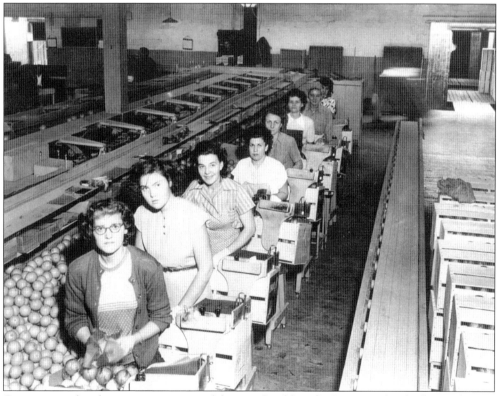

Citrus emerged as the primary commercial driver in Lordsburg/La Verne, with subsidiary industries and local infrastructure developing to accommodate the needs of grove owners. Competing railroads hastened citrus expansion by enabling choice and competitive pricing. Packing citrus was a time-consuming and tedious process. Each piece of fruit was wrapped in tissue paper to prevent bruising, which would lead to spoilage. (Courtesy of Sally [Lopez] Cardenas.)

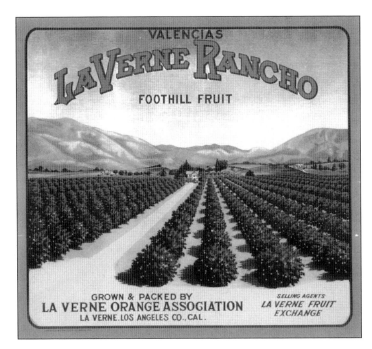

By 1909, enough citrus grove owners had settled in the area to incorporate the La Verne Orange Association. This citrus crate label advertised the grower (La Verne Rancho), packing location/organization (La Verne Orange Association), and sales agent (La Verne Fruit Exchange). The label was inspired by the grove and home of Henry C. Witmer, property that was originally developed in 1886 by Lewis Hillard and Margaret Catherine (Young) Bixby. (Courtesy of Raymond Soper.)

This 1914 photograph, looking north from Fourth Street (now Bonita Avenue), shows homes on the north side of the 2100 block of Fifth Street, including a three-story building that was moved from the area north of Foothill Boulevard. Much of the orange groves remained until the 1930s. The camphor trees in the foreground still line Bonita Avenue. (Courtesy of the WTHM.)

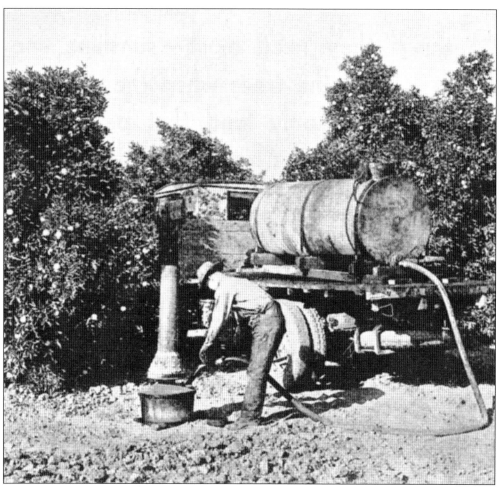

These photographs show a grove worker filling an orchard heater with oil (above) and another worker inspecting the heaters while they burn (right). Low temperatures could kill young trees and freeze citrus fruit. Growers resorted to making fires in washtubs to create smoke or "smudge." Soon, a top and smokestack were added to create an orchard heater or smudge pot, which burned crude oil. Elongated oil cans called "lighters" were used to drip burning oil into the pot, resulting in roaring fires and clouds of dark, oily smoke. The dirty job of smudging created soot that settled throughout residential and business areas. By the 1950s, smudge pots were phased out in response to air quality legislation. For a short time, wind machines were substituted. Equipped with propellers, they were mounted on poles and circulated air to prevent freezing. (Both, courtesy of the ULVWLASC.)

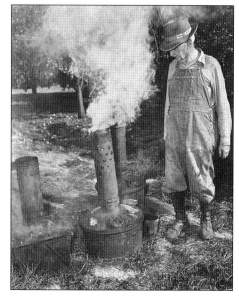

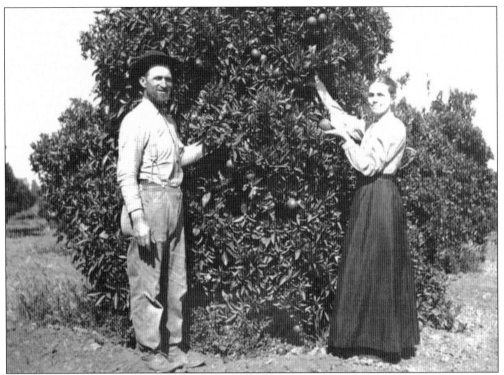

Charles and Florence (Frantz) Dresher inspect the fruit in their grove on White Avenue. Although growers often lived in homes in their groves, the Dreshers were among those who lived in town, occupying a nice home in the 2300 block of Third Street. Their home still stands and is occupied as a private residence. (Courtesy of Evelyn Hollinger.)

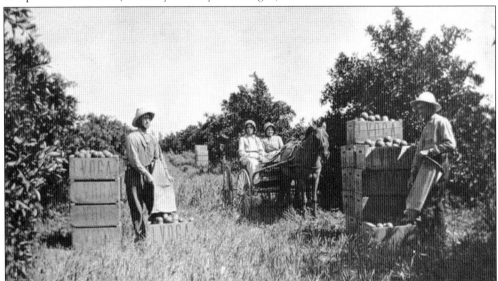

Oranges are being picked for sale through the La Verne Orange Growers Association. Workers picked citrus into canvas bags and dumped their loads into field boxes. After field boxes were loaded onto wagons for transport to packinghouses, the fruit was cleaned, graded, and individually packed into crates for shipping throughout the United States. (Courtesy of Evelyn Hollinger.)

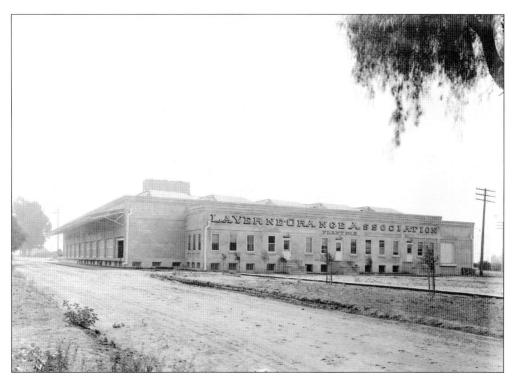

The packinghouse pictured above was known as La Verne Orange Association Plant No. 2. It was built in 1920 at the southeast corner of First and E Streets on property formerly occupied by La Verne Lumber Company. It now houses several offices of the University of La Verne. The picture below depicts newly planted citrus trees with the packinghouse in the background. (Both, courtesy of the ULVWLASC.)

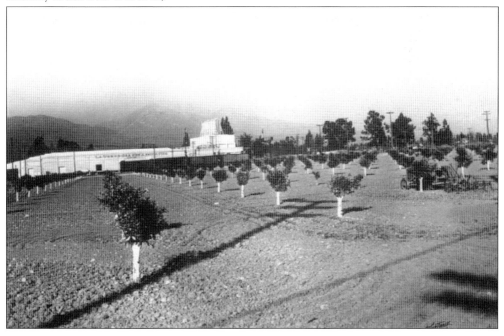

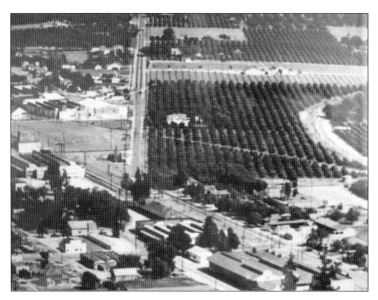

The former P.J. Yorba ranch is seen in the center of this eastward-looking view of the southern part of La Verne. Across what is now Arrow Highway is the La Verne Cooperative Citrus Association Packing Plant. In the lower left is the Hanawalt House, now on the ULV campus. The La Verne Lumber Company is just above the lower right. (Courtesy of the City of La Verne.)

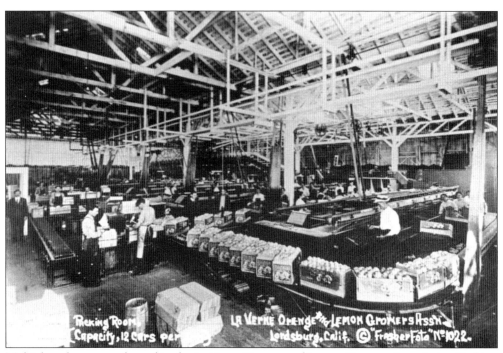

Multiple tasks were performed in the La Verne Orange and Lemon Growers Association Packing House at Lordsburg. Most notable were the graders, who sorted the fruit by size and condition; the packers, who placed the fruit in the boxes; and the box makers, who made the boxes from the slats that are seen in bundles in the left foreground. (Courtesy of FFC/HJG.)

Women pack oranges inside a multi-story packing plant. Note the line of women sorters at a higher level across the back of the photograph. Citrus-packing plants provided employment opportunities for women and reflected the commingling of workers of differing ethnicities. (Courtesy of Sally [Lopez] Cardenas.)

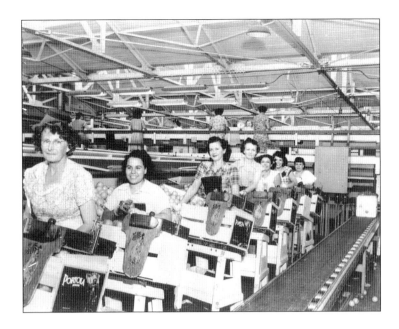

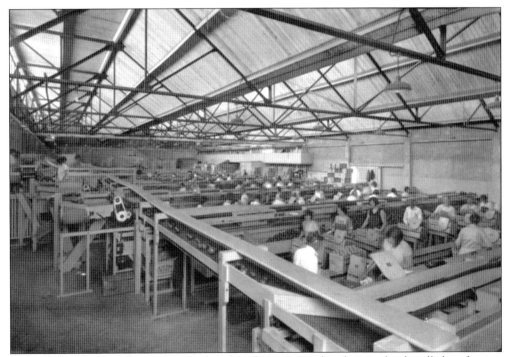

This interior photograph is representative of the five citrus packinghouses that handled production at the height of the industry in La Verne. Packinghouses were located along railroad lines to facilitate shipping. As the citrus industry declined, the packinghouses were sold for their land value and replaced with industrial businesses. Of the remaining packinghouse structures in La Verne, two are used for university purposes. (Courtesy of the ULVWLASC.)

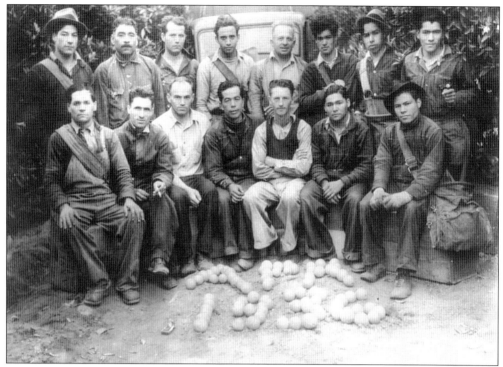

This photograph was taken for a picking crew celebrating the 1936 harvest. The pickers are, from left to right, (first row) Jesus Fuentes, Amador Lopez, unidentified, Manuel Hurtado, unidentified, Juan Zavala, and Pedro Oreño; (second row) three unidentified men, Jesus Gonzalez, unidentified, Eugene Lopez, Manuel Guerrero, and Joe Zavala. (Courtesy of Sally [Lopez] Cardenas.)

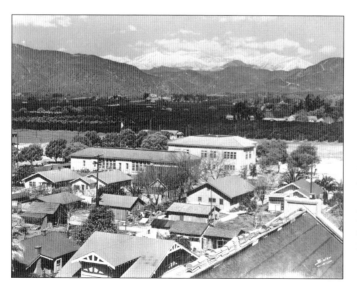

This 1930 aerial view depicts the Evergreen Ranch with its vast citrus groves north of the city. Purchased in 1904 by Valentine Peyton for $55,000, the ranch was upgraded with a new irrigation system, soil fertilization, and four new houses for ranch workers. The former ranch property is now occupied by many homes, a United Methodist church, a shopping center, a high school, a public library, and city hall. (Courtesy of the LVHS.)

This delightful citrus crate label advertises the La Verne Heights Fruit Company, whose selling agent was the Randolph Fruit Company. Crate labels were produced from the 1880s to the late 1950s and portrayed scenes of idealized beauty (landscapes, fruits, vegetables, and flowers), romanticized heritage (California missions), and even movie stars. Today, original and colorful citrus crate labels are highly collectible. (Courtesy of the ULVWLASC.)

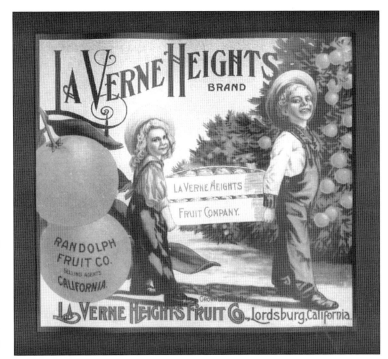

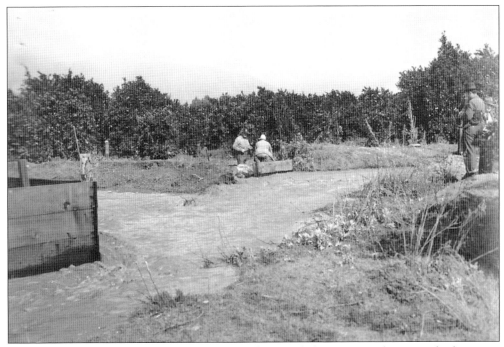

The March 3, 1938, edition of the *La Verne Leader* provided suggestions for caring for fruit trees affected by the recent severe flood. Growers were warned to wait for silty soil to dry out before shoveling it away from plant bases. Brown rot gummosis was another danger to trees whose bases had been smothered by dirt. This photograph shows excess water being channeled away from groves. (Courtesy of the La Verne Police Department.)

ENTRE NARANJOS CAFE

NICHOLAS DIAZ, Prop.

Foothill Blvd.

La Verne, California

Telephone 1512

This 1944 advertisement from the Bonita Union High School *Echoes* yearbook promoted a popular local café. Literally translated to English as "among orange trees" and reflecting pride in La Verne's citrus heritage, this small restaurant featured authentic Mexican cuisine. (Courtesy of the LVHS.)

WIE MAN
ZITRONEN
PFLÜCKEN MUSS

Emergency Farm Labor Leaflet. No. 10.G.

Co-operative Extension Work
in
Agriculture and Home Economics
University of California
and
United States Department of Agriculture
Co-operating.

1-45.

This instruction pamphlet was printed in German for use by World War II prisoners of war who were interned at the nearby Los Angeles County Fairgrounds. The US Department of Agriculture cooperated with the University of California to produce citrus-picking instructions in several languages. (Courtesy of the LVHS.)

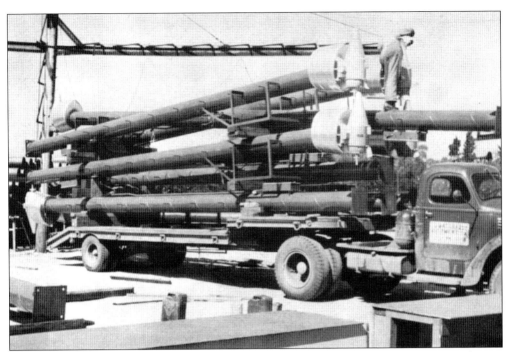

Robert J. Zievers, developer of the first automatic electric wind machine for deciduous and citrus trees, built an office/manufacturing plant in La Verne at what is now 2282 Arrow Highway in 1951 after beginning his business in Pomona. He manufactured Frostmaster Wind Machines and Scream Master Air Raid Sirens. Electric wind machines were cutting-edge technology of the time, replacing oil-burning smudge pots for preventing fruit from freezing. Air-raid sirens reflected the national fears of nuclear war. These photograph advertisements appeared in the Bonita Union High School *Echoes* yearbook in 1951 (above) and 1953 (below). (Both, courtesy of the LVHS.)

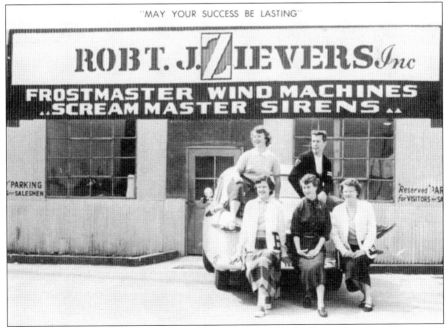

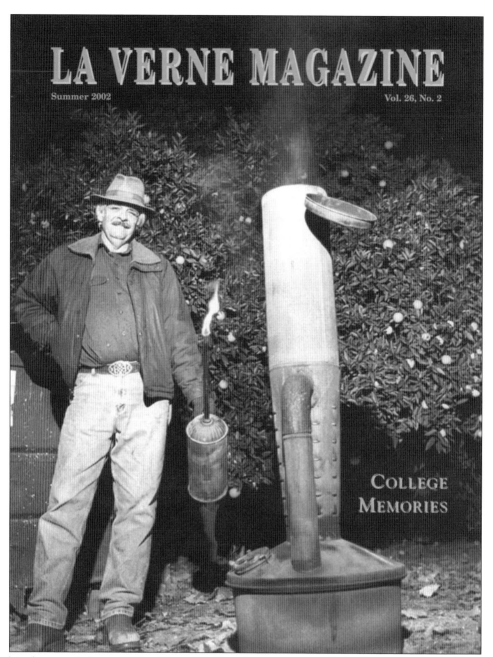

LA VERNE MAGAZINE

Summer 2002 Vol. 26, No. 2

COLLEGE MEMORIES

This photograph from a 2002 edition of *La Verne Magazine* shows Galen Beery posed at La Verne's Heritage Park with smudging equipment. As a teenager, Beery worked with smudge pots, which was expected of many young men who lived near groves. Typically, smudge pots contained enough oil to burn for eight to nine hours and were lit when temperatures went to 28 degrees Fahrenheit or lower. Once outside temperatures were sufficiently warm, the top of the smudge pot stack and hatch were closed to cut off airflow. Smudging was not generally hazardous, and the only potential harm was lack of sleep. Youngsters who "smudged" during cold nights were excused from attending school the following day. Galen Beery, president of the La Verne Historical Society for over 20 years, lost his life in an automobile accident in 2015. (Courtesy of *La Verne Magazine*.)

Five

POSTWAR GROWTH AND CHANGE

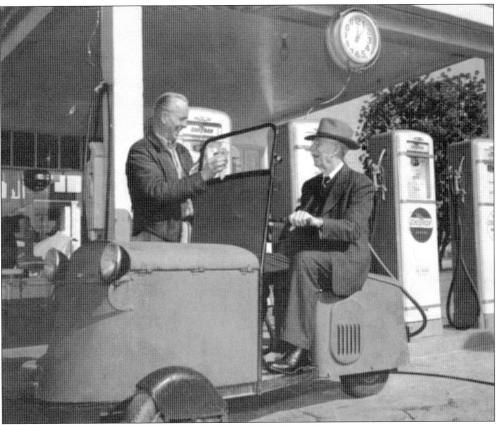

This photograph from the early 1950s shows Ben Wells at his Chevron station on the northeast corner of Fourth and D Streets. He is cleaning the windshield of the three-wheeled motor scooter ridden by 87-year-old La Verne resident Henry Marshall, a retired Standard Oil representative and trotting horse enthusiast. During his cowboy days, Henry Marshall rode through much of the United States and Mexico driving herds of cattle to market. (Courtesy of Andrea Baker.)

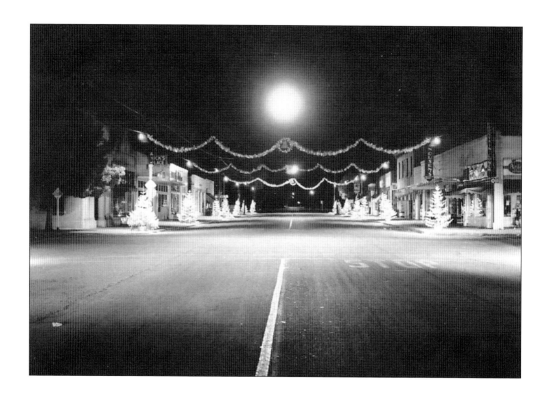

The photograph above, most likely taken in the late 1940s, shows the main street of downtown La Verne on a peaceful and still December evening. In the late 1960s, the photograph below depicts the evolution of downtown La Verne. A block north, at the main intersection of D and Fourth Streets, two of the three gas stations were soon to be replaced with a savings and loan and a donut shop. The third of these lots became a "pocket park" that is owned and maintained by the city. The fourth lot was originally occupied by a house, became a bank, was purchased by the University of La Verne and operated as its bookstore, and is now a thriving restaurant. (Above, courtesy of the La Verne Police Department; below, courtesy of the LVHS.)

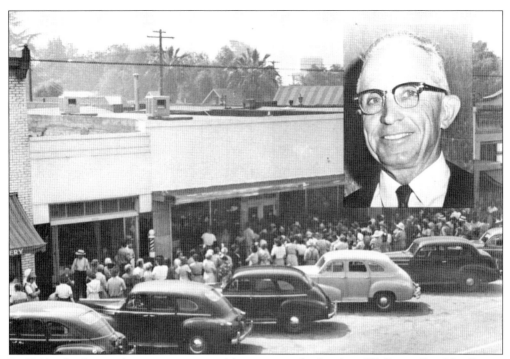

In 1946, after having businesses in several locations on both sides of D Street, Ray Van Dusen created the Van Dusen Department Store by having several buildings remodeled into one long building (2316 D Street) with sections for dresses, children's clothing, men's wear, yardage, notions, hardware, and appliances. This photograph depicts Van Dusen's grand opening on July 18, 1946, with an inset photograph of Ray Van Dusen. (Courtesy of *La Verne Magazine*.)

After using a horse-and tractor-drawn sweeper for 30 years, La Verne purchased its first motorized unit in 1948. It is shown here in front of city hall with city superintendent Ernest Snell (center) flanked by councilmen Harvey Hayes (left) and Walter Smith (right). (Courtesy of Evelyn Hollinger.)

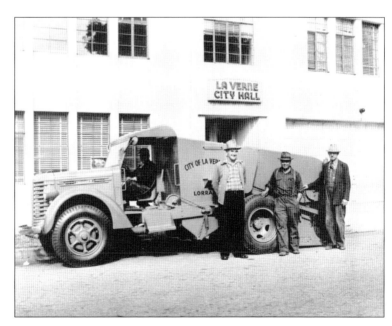

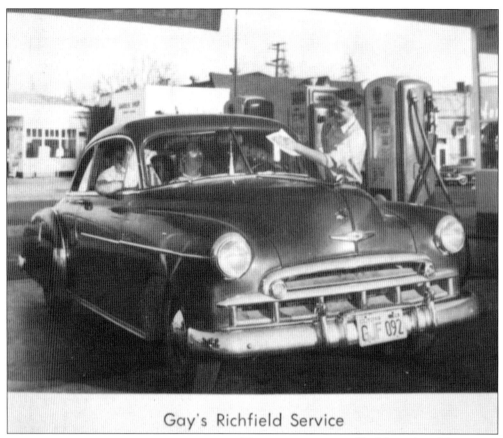

Gay's Richfield Service

The service stations of La Verne found La Verne College to be a great resource for students looking for extra income. This 1956 yearbook photograph shows Galen Beery working as an attendant at Gene Gay's Richfield station on the southwest corner of Fourth (now Bonita Avenue) and D Streets. (Courtesy of the University of La Verne.)

Hubert Taylor "Scubie" Mills came to Lordsburg in 1905 and worked for the post office from 1910 to 1955 as a rural mail carrier. Always active in civic affairs, he was a volunteer firefighter for 50 years. He was honored as Citizen of the Year by the La Verne Chamber of Commerce in 1973. In 1980, the new public safety facility was dedicated to him, Harvey Case, and Harry Blickenstaff. Mills Park, on Wheeler Avenue, was named in his honor in 1989. (Courtesy of Evelyn Hollinger.)

Harry Blickenstaff joined the volunteer La Verne Fire Department in 1931 and eventually became the first paid member of the department on a part-time basis. In 1962, he became a full-time fire chief. In 1967, he was honored with the Citizen of the Year award by the La Verne Chamber of Commerce. Upon retiring in 1972, he received a bell from the 1949 Dodge fire truck that he drove to La Verne from the manufacturer in northern California. (Courtesy of Bill Lemon.)

Roberta's Village Inn has been an iconic part of La Verne's D Street business district. Opened as the Village Inn in 1969, the name changed to Roberta's Village Inn in 2001 when Roberta Virgin, originally a waitress at the café, bought the business. Now under new ownership, Roberta's remains an informal meeting place for many, offering "American" food in a casual diner atmosphere. (Courtesy of John Best.)

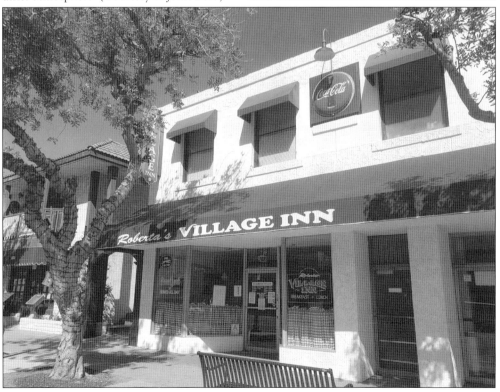

An Etiwanda native and former member of the Claremont Police Department, Harvey Case began serving as the La Verne chief of police in 1942. During his career, he organized new programs to enhance the department's effectiveness, including the city's first mounted police and reserve officer units. He was a member of the Lions Club, the Methodist Church, and the National Peace Officers Association. He was named Citizen of the Year by the La Verne Chamber of Commerce in 1960. (Courtesy of Evelyn Hollinger.)

Police chief Harvey Case formed the Junior Rifle Safety Club in conjunction with the Lions Club. The members, aged 11 to 18, were taught the safe use of firearms. They are shown at their firing range in the basement of the remains of a citrus packinghouse. (Courtesy of the LVHS.)

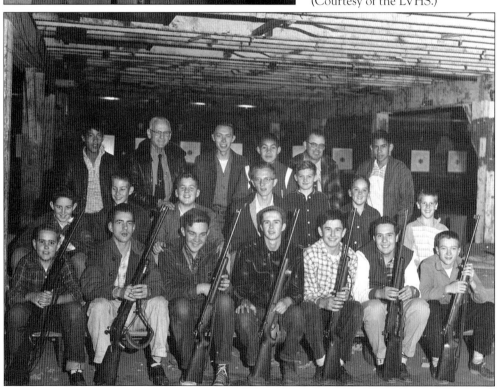

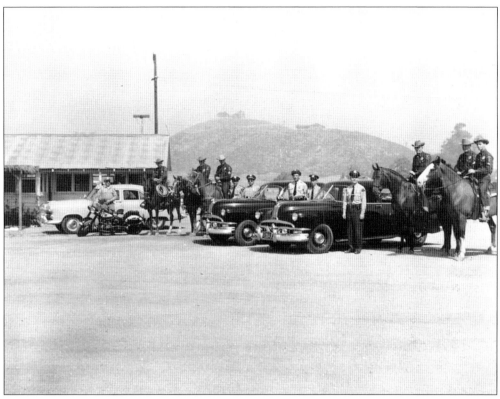

As early as 1952, La Verne had a mounted police unit organized by chief of police Harvey Case. The mounted police unit became official in 1964 and was used for crowd control, missing person searches, and representing La Verne in parades. In this photograph, the early mounted unit is shown at Brackett Field in La Verne. (Courtesy of the LVHS.)

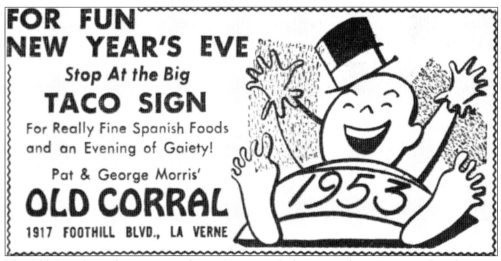

The Old Corral was the successor of Entre Naranjos Café. It was a favorite eating place for many as they traveled through the citrus groves on Foothill Boulevard (Route 66). This advertisement appeared in the *Los Angeles Times* on December 28, 1952. (Courtesy of Newspapers.com.)

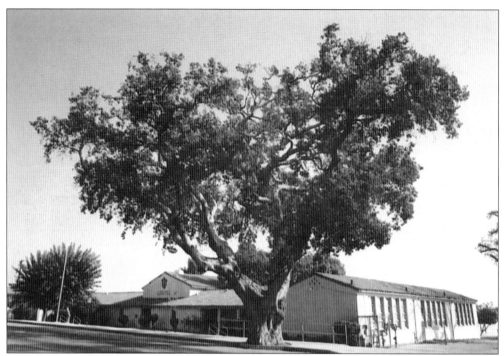

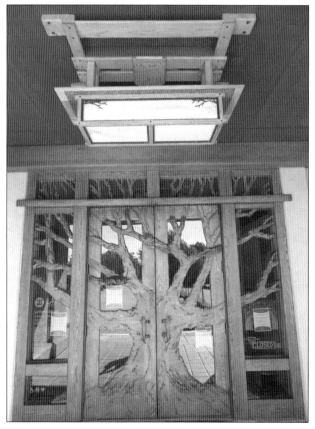

An ancient oak tree once graced the front of the La Verne Heights Elementary School (above). After it became diseased and could not be saved, the tree was cut down in 1984, and its wood was used to create several iconic features in the city, including doors for both the La Verne Library and the chapel at Hillcrest, a local retirement community. Local artist Ruben Guajardo carved the doors for the La Verne branch of the Los Angeles County Public Library (left). A lifelong La Verne resident, Guajardo uses wood exclusively for his artistic creations. (Above, courtesy of La Verne Magazine; left, courtesy of John Best.)

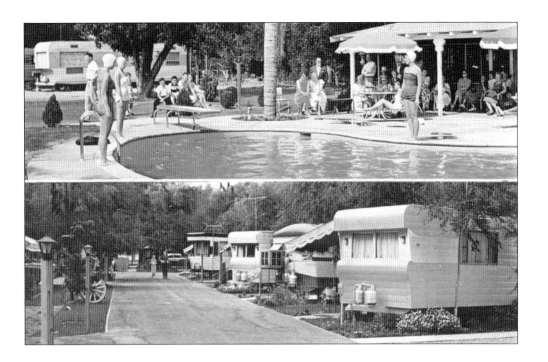

La Verne's first mobile home park (called the Valley Rancho Trailer Park in this 1957 postcard) was initially called the La Verne Tourist Camp. In addition to lots for trailers, it included a store, laundry facilities, and a service station. It is now called Valley Rancho Mobile Park and is owned by the City of La Verne. Like many of today's mobile home parks, Valley Rancho began life as an orange grove (below). (Above, courtesy of Bill Lemon; below, courtesy of Don Hauser.)

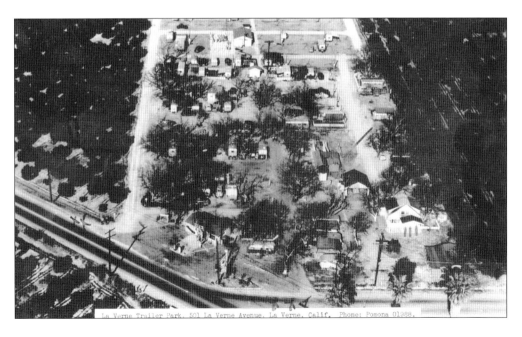

World War II brought changes to the David & Margaret Home. In 1948, a decision was made to only house children over six years of age, and the nursery group was phased out. Referrals from juvenile hall and social-work services were added in 1958, and by 1959, the home had become a member of the Child Welfare League of America. In 1968, the home began housing only adolescent girls. (Courtesy of DMYFS.)

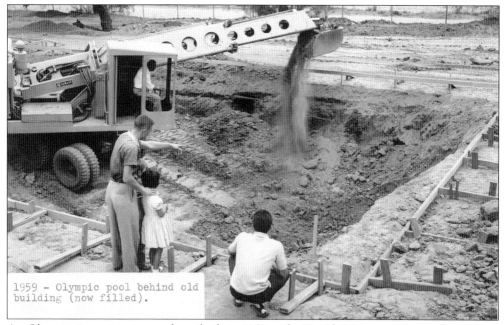

1959 - Olympic pool behind old building (now filled).

An Olympic-size swimming pool was built in 1959 at the David & Margaret Home. It was later filled in, and a small swimming pool was installed in front of the administration building. (Courtesy of DMYFS.)

Cheerleaders at the David & Margaret Home demonstrate school spirit. A state study in 1967 found that a 10:1 ratio of boys to girls for residential beds necessitated more policy adjustment, and in 1968, the David & Margaret Home began housing only adolescent girls. In 1989, the Joan Macy School opened to serve residents onsite. (Courtesy of DMYFS.)

Hands-on learning was practiced many years ago at Lincoln School (the site of what is now Roynon Elementary School) as a means to learn and acquire skills through handcraft-based creativity. This teaching method, called "Sloyd," represented a departure from paper-based academic subjects. In this photograph, students are building wooden boats to be floated in a concrete model harbor. Sloyd was popular throughout the 1950s. (Courtesy of the LVHS.)

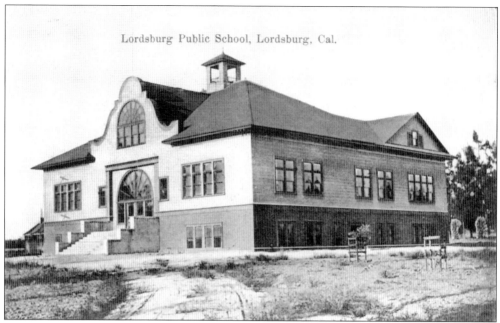

Lordsburg Public School, Lordsburg, Cal.

These images depict the evolution of public school building design. The Lordsburg Public (Grammar) School (above) was built in 1906 near the northeast corner of D and Sixth Streets. In 1922, classroom wings were added, and in 1926, the main building was re-roofed to match the wings. In 1928, the name was changed to Lincoln School. A new Lincoln School was built to the north and east in 1951, and the old school was demolished. The new school (below) was renamed J. Marion Roynon School in 1957, in honor of the retiring superintendent. Roynon School is still in use today. (Both, courtesy of Bill Lemon.)

When the new Bonita High School campus opened in 1959 at 3102 D Street, it was incomplete. Most notable among the missing facilities was the gymnasium. Prior to the construction of a new gym, the gyms at California Polytechnic University at Pomona and other schools were utilized. This photograph from the 1961 Bonita High School *Echoes* yearbook shows students watching the gym under construction. (Courtesy of Bill Lemon.)

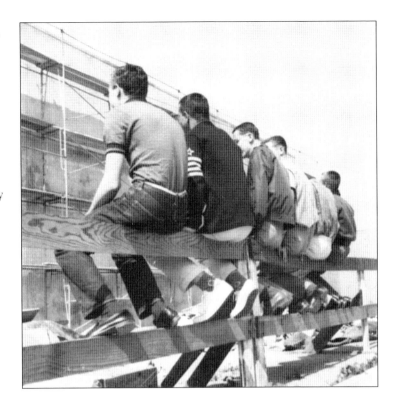

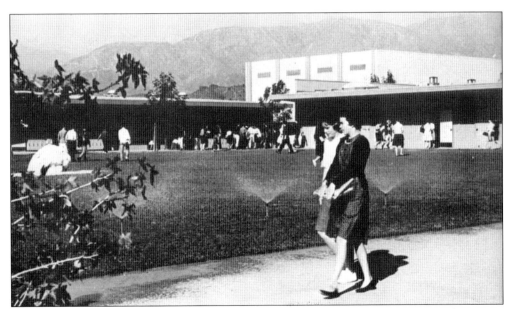

High school students stroll beside the quad at Bonita High School in 1963, with classrooms and the gymnasium in the background. The original Bonita Union High School had been sold to the Archdiocese of Los Angeles and became Pomona Catholic Boys' High School, renamed Damien High School in 1967. When first opened in 1959, the new Bonita High School lacked an auto shop, band room, separate locker room for boys, and gymnasium. (Courtesy of Bill Lemon.)

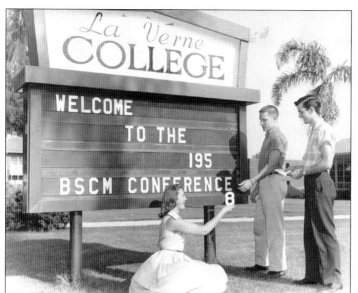

In 1958, the Brethren Student Christian Movement was held from December 29 to 31 at La Verne College for the first time in the life of this organization. The conference theme was "Do Dunkers Dabble or Dig—in the Arts, Recreation, and World Action?" Brethren students from other campuses were invited to attend. (Courtesy of the ULVWLASC.)

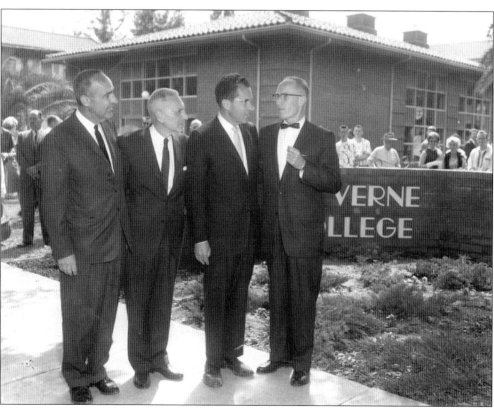

In 1962, Richard M. Nixon (second from right) was running for governor of California and stopped at the University of La Verne (then called La Verne College) for a visit. He is seen in this photograph talking to, from left to right, La Verne College trustees Ernie Carl and Fred Harmsen and La Verne College president Harold Fasnacht. (Courtesy of the ULVWLASC.)

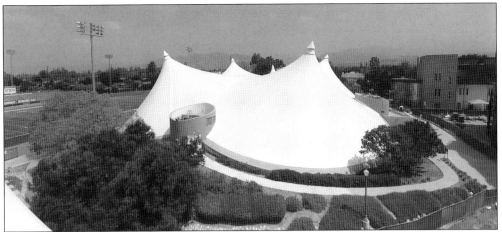

The University of La Verne "Super Tents" were first used in 1974 as a student center, including a gymnasium, when the institution was still known as La Verne College. Made of fiberglass and Teflon, this was the first permanent enclosed fabric-roofed structure in the United States, with materials in tension rather than compression. The tents now serve the athletics department. (Courtesy of Bill Lemon.)

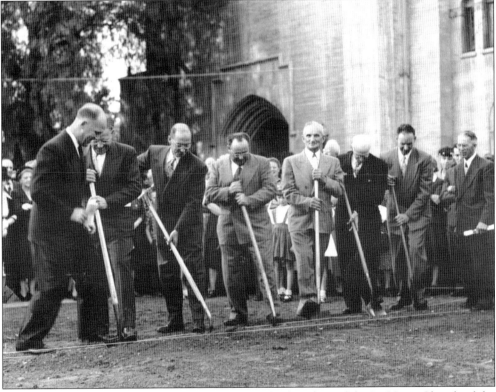

A celebration in 1950 for the 60th anniversary of the founding of the La Verne Church of the Brethren included a ground-breaking for the new administration building. Members of the building committee manned the shovels. Pictured from left to right are Pastor Galen Ogden, J. Marion Roynon, Roland Brownsberger, Ernest Snell, J. Ross Hanawalt, Will Flory, Lynn Ebersole, and building superintendent Will Moomaw. (Courtesy of the La Verne Church of the Brethren.)

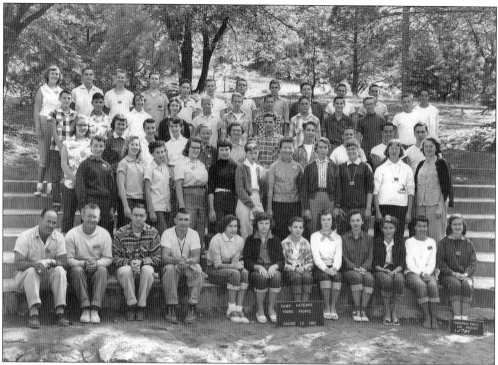

Young adults pose for a photograph at Camp La Verne in 1955. Located on land leased from the US Forest Service and operated by the Church of the Brethren in the San Bernardino Mountains since 1924, Camp La Verne continues today with Brethren-sponsored summer and winter camps. Camping was very popular at a time when youth sports, social media, and other distractions were not as available to children and youth. (Courtesy of the LVHS.)

The La Verne United Methodist Church was built in the early 1960s on property that once was part of the Evergreen Ranch, one of the earliest and largest citrus ranches in La Verne. This building was the location of a famous final scene between Dustin Hoffman and Katharine Ross in the 1967 film *The Graduate*. (Courtesy of John Best.)

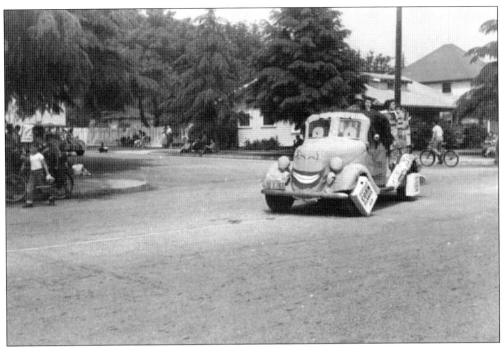

La Verne's Blossom Time Festival was a four-day event, beginning on Wednesday afternoon with a carnival and booths in the city park and continuing until the evening. The next two days hosted the same events, with a flower show and queen coronation on Friday. Saturday included an afternoon parade and evening square dance. This 1949 photograph depicts a whimsical parade entry from the La Verne Food Market. (Courtesy of George Beckman.)

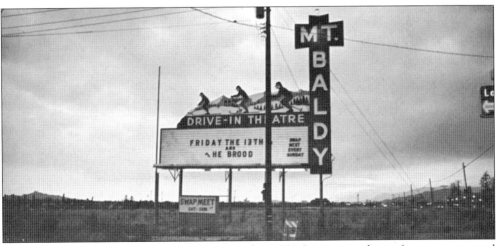

The Mt. Baldy Drive-In Theatre was constructed in 1960. It was carved out of a citrus grove and served La Verne and the surrounding communities into the 1980s as both a theater and a swap meet. The groves are now long gone, and the land has been occupied by the La Verne Post Office since 1999. (Courtesy of *La Verne Magazine*.)

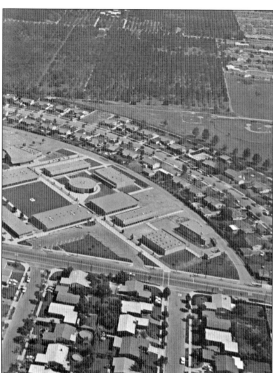

This photograph is one half of a two-page spread in the 1964 Bonita High School *Echoes* yearbook depicting the Bonita High School campus. In the upper right, one can see new building construction encroaching on citrus groves that once covered a large part of La Verne (Courtesy of Bill Lemon.)

Hillcrest reflects a community's response to citizen needs. Originally established in 1947 as a Brethren "Home for the Aged," Hillcrest consisted of 10 cottages on six acres that had been a lemon grove and chicken ranch. Evolving over time to meet community and healthcare needs, Hillcrest's west and east complexes cover 50 acres with numerous living options. This photograph shows the east complex in the 1960s. (Courtesy of Hillcrest Retirement Community.)

Six

MAKING HISTORY TODAY

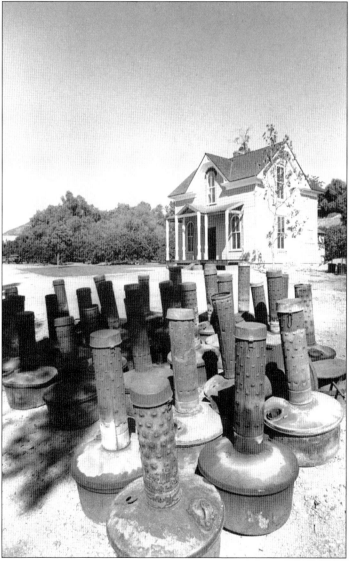

In 1984, a member of the La Verne City Council successfully advocated for the creation of a heritage park to celebrate the city's citrus history. Located on four acres, the site includes a heritage farmhouse, barn, several outbuildings, and assorted farm equipment. Orange picking, tractor rides, house tours, and educational/ interactive experiences are offered to visitors and school groups. A collection of orchard heaters, better known as smudge pots, are in the foreground. (Courtesy of *La Verne Magazine*.)

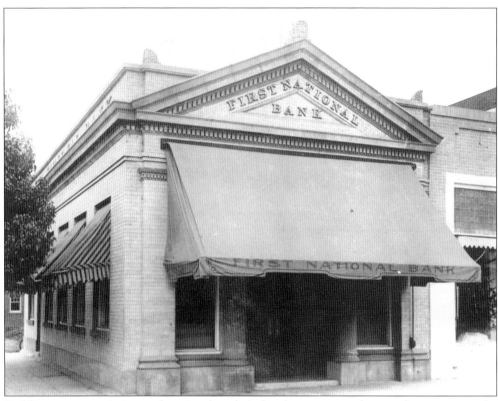

Buildings may remain in one location, but their facades, street numbers, and purposes can be fluid. The photograph above is of the First National Bank of Lordsburg, built in 1909–1910. When the address was first assigned, it was numbered 303 North D Street. The business became the First National Bank of La Verne in 1917. In 1927, the address changed to 2307 D Street, as all city addresses changed by city ordinance. In 1954, a new bank building was erected one block north. Several businesses have operated in this location, including stores selling fabric, landscape lighting and engineering, party/gift supplies, and carpets. The present occupant is Aoki Japanese Restaurant (below). (Above, courtesy of the LVHS; below, courtesy of John Best.)

The Inland Dairy drive-through at 2055 White Avenue has been in operation since 1965. It provides a convenient service on a busy thoroughfare. Drive-through restaurants and convenience stores remain popular in California, where cars are a dominant aspect of popular culture. (Courtesy of Bill Lemon.)

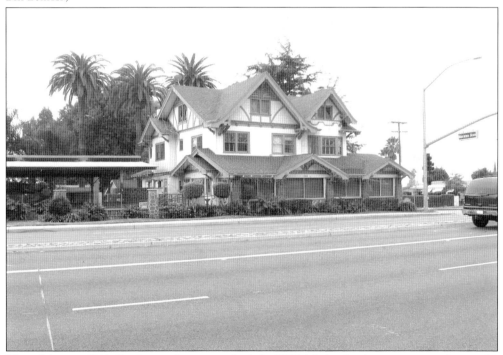

This elaborate 1911 Craftsman home was built by W.T. Michael, who was a caretaker at the Palomares Adobe in Pomona and later worked for one of the largest citrus nurseries in San Dimas. Michael was successful in the realty business and operated locations in Pomona, Los Angeles, and San Dimas, as well as Lordsburg. One of Lordsburg's largest homes, the Michael residence has operated since 1977 as a restaurant. (Courtesy of Bill Lemon.)

This business park and warehouse facility represent the face of commercial development in modern La Verne, featuring an onsite restaurant and convenient freeway access. Opened in 1989, the park is located north of Brackett Airport, and its streets are named after notables in aviation history, including Yeager, Earhart, Curtiss, and Wright. (Courtesy of Marvin Weston.)

Gilead Sciences, Inc., an American biotechnology company founded in 1987, researches, develops, and commercializes drugs with a focus on antivirals used in the treatment of HIV, hepatitis B, hepatitis C, and influenza. This Gilead office opened its 400,000-square-foot manufacturing plant in 2017 on 23 acres in a south La Verne business park. Gilead employs 500 people and is an example of evolving commercial development. (Courtesy of Marvin Weston.)

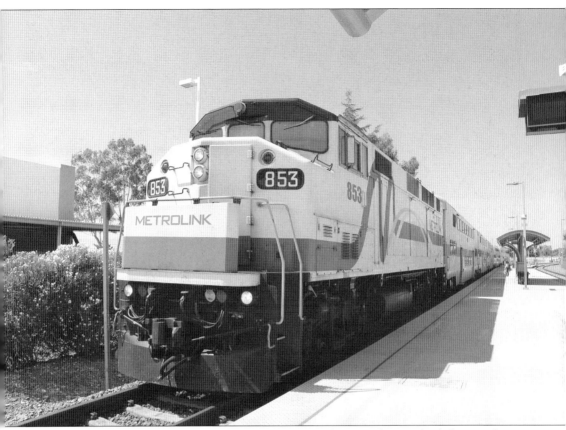

Metrolink provides commuter rail service in Southern California along multiple lines and over more than 500 miles of rail network. Founded in 1992, Metrolink operates in Los Angeles, Orange, Riverside, San Bernardino, San Diego, and Ventura Counties. Metrolink is complemented by the light rail system known as the Metro Gold Line (now the L Line), which entered service in 2003 and will eventually include a La Verne station. (Courtesy of Marvin Weston.)

In 1977, the La Verne City Council authorized the $750,000 purchase of the former Shea Building for its new city hall. At 16,000 square feet, it was twice the size of its former quarters, which became the location for the police department. This duplicate 1975 Bicentennial Liberty Bell was secured by La Verne as a lasting symbol of heritage and freedom. (Courtesy of John Best.)

Maniero Square, located at the corner of D and Third Streets, marks a boundary between city and university property. It was recently the location of a reenactment of the 100-year-old "wedding" of Mr. La Verne and Miss Lordsburg, and future plans include a major renovation to include a permanent stage and cell phone tower. (Courtesy of Bill Lemon.)

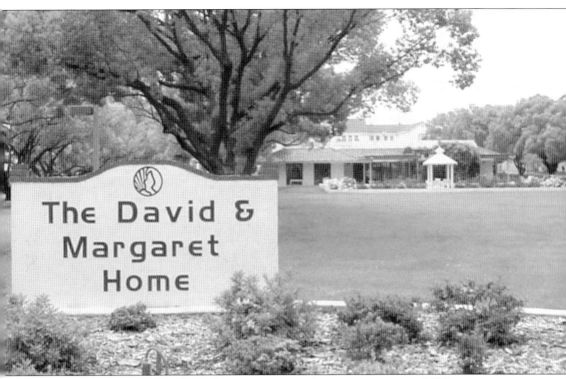

David & Margaret Youth and Family Services received its current name in 2006 in recognition of its broadening array of services and commitment to family-centered care. It offers residential treatment that serves six counties in Southern California and is the largest facility of its kind in California. A total of five cottages, a non-public school, a recreation building, a dining hall, a pool, and administrative and maintenance buildings are located onsite. (Courtesy of DMYFS.)

The north La Verne housing boom of the 1980s strained the resources of La Verne Heights Elementary School, which served the area most impacted by housing growth. Newfound financing allowed a new school, later named Oak Mesa Elementary, to be completed in 1990. Five elementary schools serve La Verne students (one of which is shared with students from neighboring San Dimas). (Courtesy of Marvin Weston.)

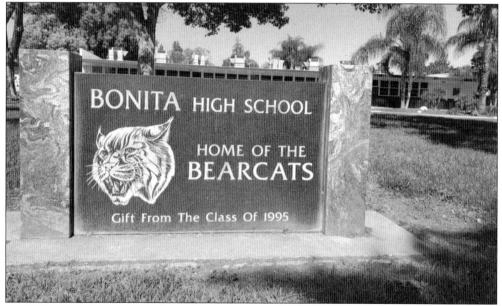

By 1905, Bonita Union High School had a permanent structure solely for educational purposes that served the communities of Lordsburg, La Verne, and San Dimas. In response to an expanding student population, the school moved to its current campus on D Street in 1959 after the previous site was sold to, and eventually operated by, the Roman Catholic Archdiocese of Los Angeles as Pomona Catholic Boys' High School. The school was eventually renamed Damien High School. (Courtesy of John Best.)

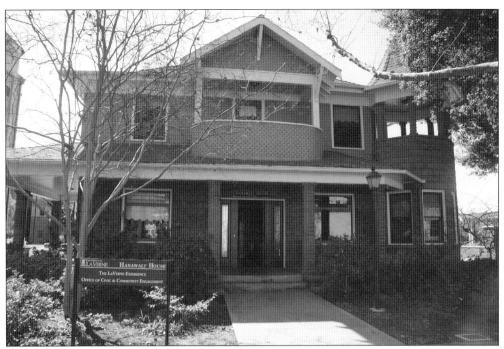

Built in 1905 by Lordsburg College president William Cyrus Hanawalt, this house was his residence during his presidency and after his retirement in 1945. The University of La Verne purchased the house in 1973, but a 2004 fire necessitated its closing. The Hanawalt House was reopened in 2009 and is currently used as an office building and campus landmark. (Courtesy of Jamie Watson.)

In 1977, ULV leased a former Alpha Beta supermarket located on the site of the Lordsburg Hotel for the university library. In 1980, it was purchased from funds donated by former students Elvin and Betty Wilson and the Irvine Foundation. The Wilsons provided more funds for the library, and in 1982, it was dedicated as the Elvin and Betty Wilson Library. Between 1993 and 1996, the library was remodeled and expanded with more financing from the Wilsons. (Courtesy of the ULVWLASC.)

In 2019, the University of La Verne's 53-year-old Interfaith Chapel was reduced to a pile of rubble. Several concerns, including disability accessibility, lack of meeting space, and a decision to broaden the center to reflect a greater diversity of faiths, drove the removal of the original chapel. (Courtesy of the ULVWLASC.)

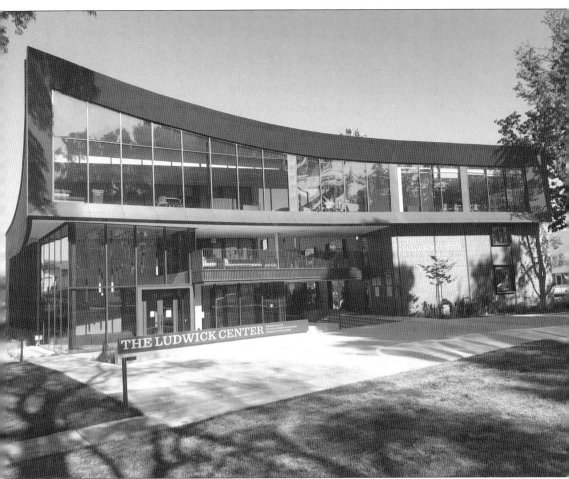

The Ludwick Center for Spirituality, Cultural Understanding, and Community Engagement stands adjacent to the site of the Interfaith Chapel. In addition to a sacred space, three classrooms, a group prayer and meditation room, a yoga and quiet room, a courtyard, and collaboration spaces make statements of inclusivity and spiritual belonging. (Courtesy of John Best.)

This sports field is located at the University of La Verne's Campus West Athletics Facility and is named after Ben Hines, a graduate of the University of La Verne and hitting coach for the 1988 World Champion Los Angeles Dodgers baseball team. Hines was head coach of the 1995 NCAA Division III National Champion University of La Verne Leopards and also scouted for the Anaheim Angels. (Courtesy of Marvin Weston.)

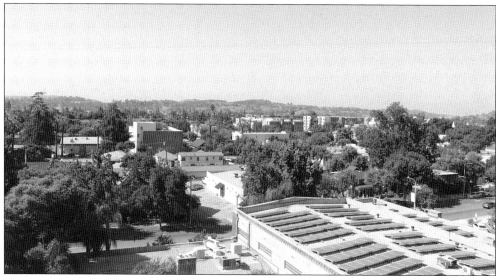

This contemporary photograph taken from the top of the Church of the Brethren bell tower faces southwest over the top of the church fellowship hall (complete with solar panels). The former post office and telephone building are to the left. In the right background are a cluster of multi-story university buildings, including student housing and a new dining hall. Many buildings and prolific tree growth make the downtown unrecognizable from earlier images of a sparsely populated area. (Courtesy of Bill Lemon.)

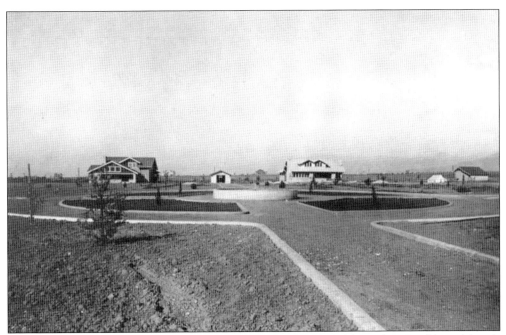

In 1911, Henry Kuns donated two and a half acres of land for a public park in Lordsburg (above). Originally named Eoline Park in honor of Kuns's wife, the park was renamed Kuns Park sometime after 1926. When he donated the land, Kuns stipulated that all houses surrounding the proposed park cost at least $5,000 to build. The photograph above faces west across the park space toward Kuns's house and that of his son-in-law, James Johnson. The photograph below depicts the park today, with numerous trees, a playground, and a picnic area. A marker celebrates the oldest tree in the park. (Above, courtesy of the LVHS; below, courtesy of Marvin Weston.)

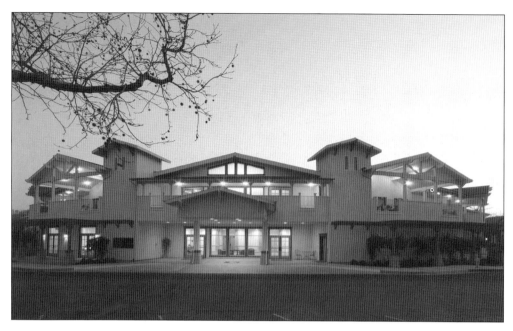

Hillcrest Retirement Community houses retired residents in cottages, apartments, and other configurations and provides different levels of care. Begun as the Brethren Home for the Aged, Hillcrest has a strong community presence. The main administration building (above) includes a meetinghouse that can accommodate up to 250 occupants for cultural events, lectures, and other community activities. A gallery is located upstairs and features the work of local artists and a yearly exhibit entitled The Story of La Verne. Hillcrest's indoor swimming pool (below) is available to residents and community members. (Both, courtesy of Hillcrest Retirement Community.)

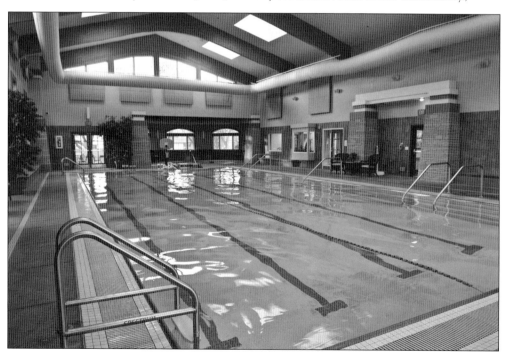

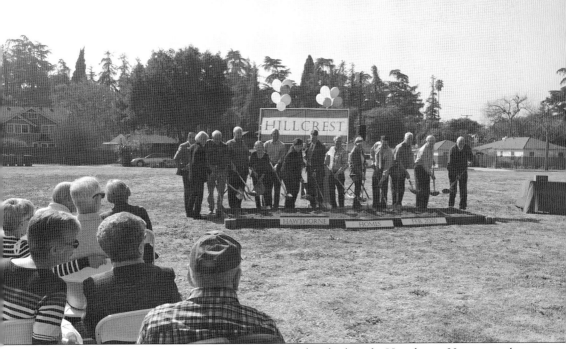

Hillcrest Retirement Community continues to expand with plans for Hawthorne Homes, single-family cottages on the west side of the complex. Hillcrest reflects the value placed on senior residents and their contributions to the city. This ground-breaking took place in February 2020. (Courtesy of Bill Lemon.)

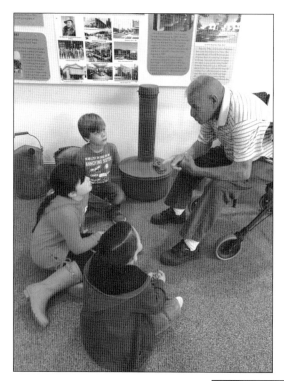

Multiple community stakeholders collaborated to produce a Hillcrest Gallery exhibit entitled The Story of La Verne, which relates events from 1887 to the present day through organizing themes of commerce, transportation, family and community life, arts and culture, education, and faith. Culture bearer Daryl Brandt tells his personal history of tending orange orchards as a child against an actual smudge pot and oil can below a panel of vintage images and historical narratives. (Courtesy of Matthew Neeley.)

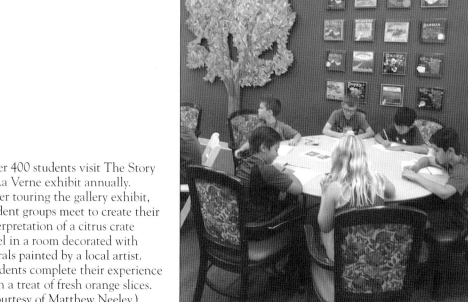

Over 400 students visit The Story of La Verne exhibit annually. After touring the gallery exhibit, student groups meet to create their interpretation of a citrus crate label in a room decorated with murals painted by a local artist. Students complete their experience with a treat of fresh orange slices. (Courtesy of Matthew Neeley.)

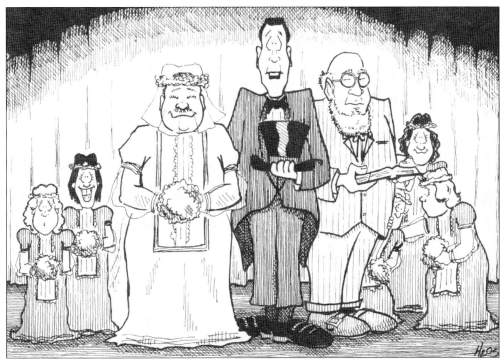

In 1917, residents of Lordsburg voted to change the name of their city to La Verne. After an affirmative vote, a mock wedding was held between Miss Lordsburg and Mr. La Verne. No photographs of the original "ceremony" remain, but the above cartoon created years later depicts the participants. Oscar Raley was the bride, and W.S. Romick was the groom. Harvey Nichols played the part of the minister, and the flower girls were Lois and Alice Durward, Lois Miller, Lola and Miriam Shirk, and Gladys and Hazel Snoke (only five are pictured). One hundred years later, the mock wedding was reenacted by La Verne residents Letha and Willard Ressler as the bride and groom, with Mayor Don Kendrick officiating (below). (Above, courtesy of Mark Waters; below, courtesy of Jamie Watson.)

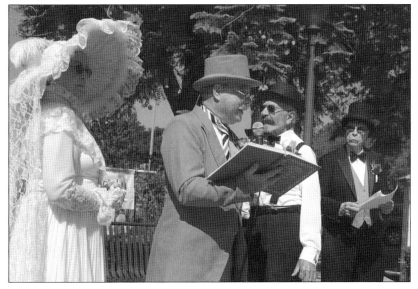

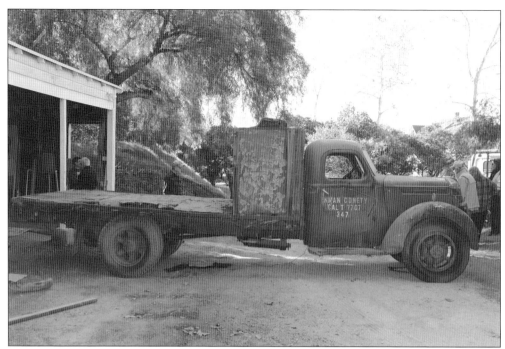

Preserving cultural resources remains an important focus of collaborative efforts between city administrative officials and the La Verne Historical Society. A 1938 International flatbed truck (above) that was owned by a previous historical society president and left to the society is currently being restored for use as an educational tool and in city events. Below, the current La Verne Historical Society president and mayor present the project to participants at a city council meeting. Community residents are involved in the restoration effort. (Both, courtesy of Marvin Weston.)

Community preservation continues today with a city-sponsored bronze marker program recognizing homes of notable persons in La Verne's history. The 1908 home of John A. Larimer, manager of one of the largest groves in Southern California, is pictured above. The image to the right shows the bronze marker placed on his property in 2010. Preserving notable homes, neighborhoods, and landscapes instills pride and provides cultural and educational benefits to community residents. (Above, courtesy of Betty Joy Banninger; right, courtesy of John Best.)

The Bradford House

John A. Larimer Home on Bradford
Craftsman Grove Home – 1908

JOHN A. LARIMER CAME FROM TENNESSEE TO LORDSBURG IN 1891 AND MARRIED SUSIE ZUG OF SAN DIMAS IN 1900. THEY RESIDED HERE FROM 1909 UNTIL 1925 OR 1926. LARIMER MANAGED THE RICHARDS ORANGE GROVE ON NORTH GAREY, ONE OF THE LARGEST GROVES IN THE WORLD.

LA VERNE
HEART OF THE ORANGE EMPIRE

HISTORICAL SOCIETY OF LA VERNE
NO. 23

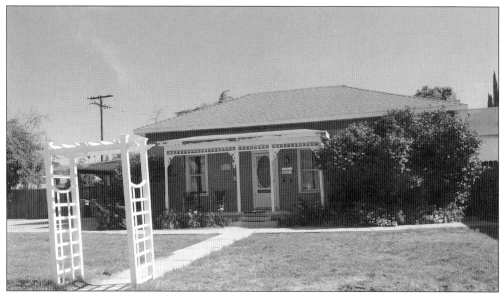

The earliest Anglo resident of what is now La Verne was "Colonel" George Heath, a teamster who came to Lordsburg in 1878, bought land from Jose Dolores Palomares, and built a small Victorian cottage on what is now First Street. Heath's daughter Mary Emma was the first Anglo child born in Lordsburg. The Colonel Heath house still functions as a private residence. (Courtesy of Bill Lemon.)

The official city seal of La Verne features themes of education, friendship, industry, transportation, and recreation. Education is depicted by the University of La Verne super tents and a graduation cap, while friendship is represented by a handshake. Orange groves depict industry as a tribute to La Verne's citrus heritage. The areas of transportation and recreation are depicted by a plane landing at local Brackett Filed and a Metrolink train. (Courtesy of Bob Russi.)

Seven

PUBLIC ART IN LA VERNE

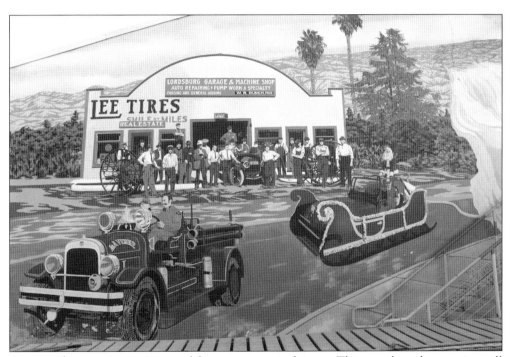

Art provides an opportunity to celebrate community history. This mural on the exterior wall of La Verne's public safety building depicts the Lordsburg Garage and Machine Shop in the background (see page 26) with a fanciful re-creation of a 1930 Seagrave 500-gallon Suburbanite triple combination pumping engine. Santa rides on his sleigh, an homage to a contemporary Christmas Day tradition. (Courtesy of Marvin Weston.)

Damien High School (formerly Bonita Union High School) is home to the oldest piece of public artwork in the city. Painted in 1939 by Grace Clements through the Depression-era Federal Arts Project of the Works Progress Administration, the *WPA Music Building Mural* was painted over and then rediscovered during a renovation at the school. (Courtesy of Marvin Weston.)

This mural re-creates a gas station that once stood on the corner of D Street and Bonita Avenue. When this mural was painted, the photograph of the actual station was not used, and the artist used a service station picture from a neighboring city. (Courtesy of Marvin Weston.)

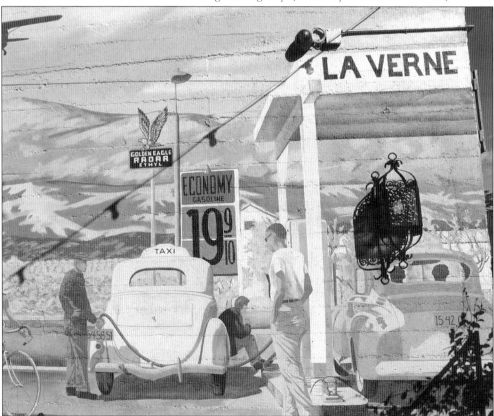

Packinghouses once lined the railroad tracks that cut through La Verne. Now repurposed, they escape dreariness with decorative murals depicting the city's citrus heritage. Viewers are reminded of La Verne's status as "Heart of the Orange Empire" in the re-created brochure (right) and orange orchards (below). The shadows cast by the lamppost and brochure mural add a painted three-dimensional aspect to the mural. The shadow cast in the image below appears to be part of the mural but is caused by an actual lighting fixture. (Both, courtesy of Marvin Weston.)

This re-creation of a citrus crate label advertises lemons and the La Verne Mutual Citrus Association. In an ironic twist, this mural is situated on the side of a packinghouse that operated as the La Verne Orange Association Plant No. 2. (Courtesy of Marvin Weston.)

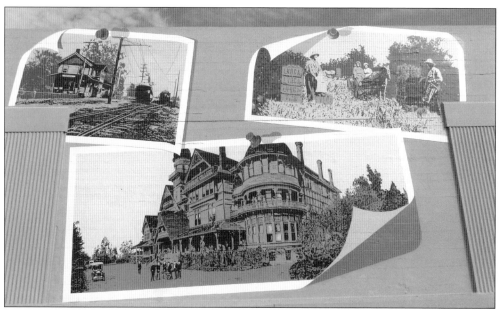

These painted re-creations of early photographs are entitled *Scrapbook*. Artists Joy McAllister and Chris Toovey painted this mural in 1992, and it was refurbished in 2017. It is located on the south side of the University of La Verne Arts and Communication Building in what is left of an original packinghouse. (Courtesy of Marvin Weston.)

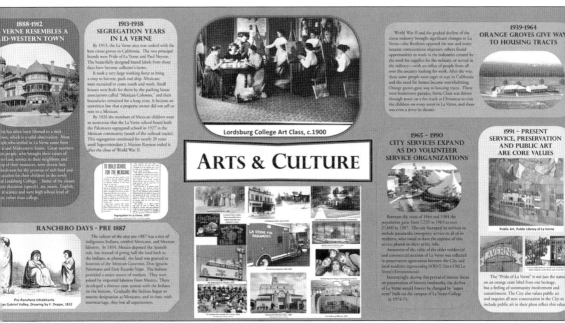

The Hillcrest Retirement Community provides annual tours of a gallery exhibit entitled The Story of La Verne. Part of the elementary school social studies curriculum, the exhibit consists of six panels explaining life from the 1880s to the present through the themes of commerce, transportation, education, arts and culture, family and community, and faith. This panel depicts the theme of arts and culture. (Courtesy of Eric M. Davis.)

La Verne celebrated the 100th birthday of the founding of the townsite of Lordsburg with a centennial quilt (1887–1987) depicting citrus orchards with the San Gabriel mountains in the background. This quilt hangs in the city community center and is an excellent example of folk fiber art. (Courtesy of Marvin Weston.)

"The Rock" is a tangible symbol of student pride at the University of La Verne. Originally painted green with an orange LVC (La Verne College), the rock was replaced in the 1960s with a large boulder from the San Gabriel mountains. The rock evolved into a place for student groups to paint celebratory announcements. Episodes of illicit repainting of the rock necessitated a reservation system for student messages. (Courtesy of John Best.)

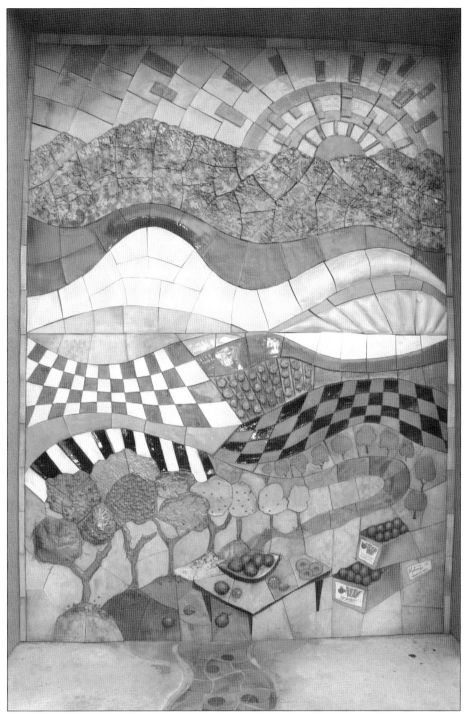

The visual illusion of trompe l'oeil was created by Frank Matranga in mosaic on the side of a popular La Verne bakery and café. Viewers are tricked by the three-dimensional appearance of the table whose fruit is "falling" onto a concrete floor. Stylized checkerboard fields and mountains "float" in the background. (Courtesy of Marvin Weston.)

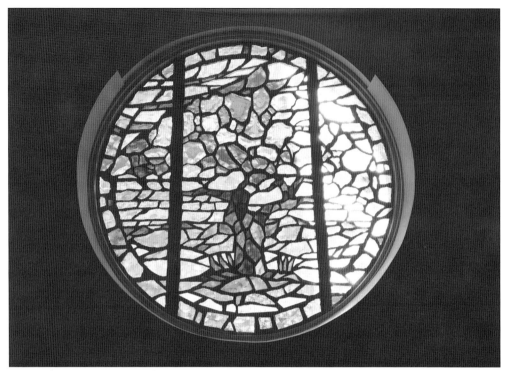

Stained glass offers a colorful medium for artistic expression. This round window at the Hillcrest Meeting House is reminiscent of oak trees found throughout the area and celebrates the oak tree removed from the property of La Verne Heights Elementary School and made into decorative doors for the county library and the Hillcrest chapel. (Courtesy of Marvin Weston.)

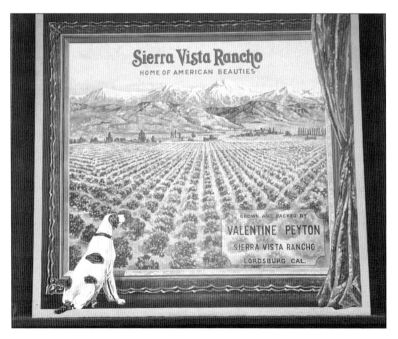

One of the largest citrus orchards in Lordsburg was the Evergreen Ranch. The property was purchased by Valentine Peyton in 1904 and named Sierra Vista Rancho. Peyton was active in its management until his death in 1932. This mural re-creation of a citrus crate label is painted on a business building. (Courtesy of Marvin Weston.)

Art was expressed in a theatrical re-creation of the lives of La Verne's pioneers in a cemetery tour sponsored by the La Verne Historical Society. The costumed docents told the story of La Verne's first doctor, Dr. John Edgar Hubble (above), while the mayor and his wife (right) told stories about his ancestors, the Bixby and Kendrick families. Margaret Bixby is credited with giving La Verne its name. (Both, courtesy of John Best.)

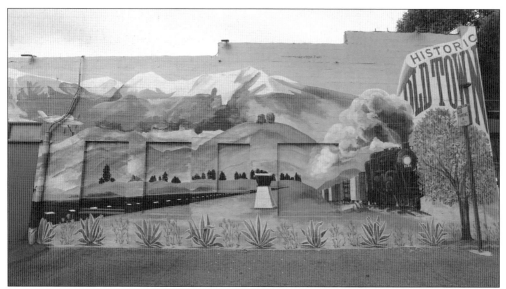

This mural uses primary colors and depicts the importance of railroads to La Verne's history. Painted by artist Eric M. Davis, the mural stretches across the back of a building in the historic downtown district. The train is reminiscent of a historical photograph by Burton Frasher. (Courtesy of Marvin Weston.)

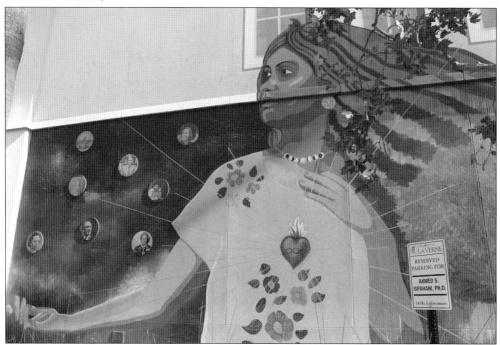

This recently painted mural graces the south wall of the University of La Verne's Wilson Library. Titled *Nevertheless . . . They Persisted* and painted by artist Kristy Sandoval as part of the university's 125th anniversary, it reflects a commitment to a supportive, inclusive, and diverse environment. The mural features a blue-haired Latina figure wearing a sacred heart, while floating before her are painted portraits of significant figures from the university's development. (Courtesy of Marvin Weston.)

The La Verne Historical Society exemplifies its motto of "Preserving Old La Verne's Environment, Making History for the Future" by filling display cabinets with historical artifacts. These "pocket museums" will be deployed for public viewing throughout the city. Refinishing the cabinets was undertaken as an Eagle Scout project by Samuel Neeley, a member of a local troop. (Courtesy of Matthew Neeley.)

This mural on the side of a popular restaurant on La Verne's Bonita Avenue reflects the pride of a community that continues to celebrate its heritage. The artist, Eric M. Davis, is a lifelong La Verne resident who has painted numerous works throughout the city. (Courtesy of Marvin Weston.)

DISCOVER THOUSANDS OF LOCAL HISTORY BOOKS FEATURING MILLIONS OF VINTAGE IMAGES

Arcadia Publishing, the leading local history publisher in the United States, is committed to making history accessible and meaningful through publishing books that celebrate and preserve the heritage of America's people and places.

Find more books like this at
www.arcadiapublishing.com

Search for your hometown history, your old stomping grounds, and even your favorite sports team.